SCOTTISH CRAFTS AND CRAFTSMEN

Michael Brander

Johnston & Bacon, Publishers
Edinburgh & London

JOHNSTON & BACON PUBLISHERS
*35, Red Lion Square, London, WC1R 4SG & Tanfield House,
Tanfield Lane, Edinburgh, EH3 5LL*

An imprint of CASSELL and COLLIER MACMILLAN
PUBLISHERS LTD.,
*35, Red Lion Square, London WC1R 4SG
and at Sydney, Auckland, Toronto, Johannesburg
an affiliate of
Macmillan Inc., New York*

First published, 1974

© Michael Brander, 1974

ISBN 0 7179 4588 8 (paperback)
 0 7179 4564 2 (cased)

*Printed in Great Britain by
The Camelot Press Ltd, Southampton*

Author's Preface

For far too long Scotland's image abroad has been marred by tawdry tartan dolls and similar cheap souvenirs, generally manufactured in Hong Kong, or elsewhere, but in any event bearing as little relationship to Scotland or Scottish craftsmanship as Piccadilly Circus. To write a short book on Scottish Crafts and Craftsmen principally for the visitor to Scotland it is essential to include a clear background outline of how the crafts developed. In the process it has been necessary to go a little beyond the scope of the title on occasion. I make no apologies therefore for going into the origins of tartan at some length, or for including a brief mention of the Highland Games and Curling, both essentially Scots. To appreciate Scottish crafts and craftsmanship it is important to know something of the background of Scotland. Like Scotland itself, Scottish crafts have a considerable history, each interwoven with the other. There is still fine Scottish craftsmanship available in many fields today, but in order to discriminate between the truly Scots and the less authentic it is necessary to know the background. It is with this aim in view that this book has been written.

Acknowledgments

The author and publishers wish to acknowledge the help of the following in supplying colour transparencies and black and white photographs for this book:

Cover John R. Dalgety for the Smith Tartan; The Highlands and Islands Development Board Photographic Library for Caithness Glass; John Dickson and Son, Gunmakers, Edinburgh, for the gun and the Scottish Tourist Board for the Clarsachmaker.

Text Colour transparencies: Patrick Hamilton for the Kiltmaker, the Tapestry Weaver and making Lobster Pots; The Highlands and Islands Development Board Photographic Library for The Glass Engraver and the Woodcarver and the National Museum of Antiquities of Scotland for the Powder Horn (catalogue number LK 7), Fishtail Butts (cat. nos. LH 325 and LH 326), and Targe (cat. no. LN 49) and Broadsword (cat. no. SW 23). Black and white photographs: The Amen Glass, courtesy of The National Museum of Antiquities of Scotland; the rest of the black and white photographic material was specially taken for the book by Patrick Hamilton. The map of Scotland was prepared by John F. Martin, Reiver Design, Galashiels.

We would like to thank the many people, organisations and craftsmen who gave us invaluable assistance in the preparation of this book and in particular the following:

Mr. James Carson, Director, of the Scottish Crafts Centre, Edinburgh; The Small Industries Council for Rural Areas, Edinburgh; Kilspindie, Haddington; The Duke of Hamilton, Lennoxlove, East Lothian; The Lamp of Lothian Trust; The Eyemouth Boat-Building Company Limited; Adam Paterson & Sons Ltd., West Mill, Haddington; James Kirkpatrick, Kilt-maker & Bagpipe-maker, Bonhill; Dorothy Urquhart, Tapestry Weaver, Edinburgh; Ben Sayers, Golf Club-makers, North Berwick; J & R Glen, Bagpipe-makers, Edinburgh; William Main, Saddle-makers, Dunbar, and W. E. Scott, Sporran-makers, Edinburgh.

Introduction

Basically Scotland is composed of the Highlands and Islands, the Lowlands and the Borders. Although together they make up the Scottish nation each has distinct and differing origins and history and each has its own particular crafts associated with it. The Highlands and Islands, therefore, have Celtic and Norwegian influences at work in their crafts, the Lowlands show traces of French and Low Country influences in theirs, while the Border craftsmen, as might be expected, have a kinship with some north country crafts found in England.

In considering Scottish crafts, however, it must always be borne in mind that Scotland and England were separate and often warring nations until the Union of the Crowns under James VI of Scotland and I of England in 1603 and that it was not really until the Union of the Parliaments in 1707 that a first measure of unity between England and Scotland was achieved. Even then the Union was strongly opposed by many influential Scots and a large part of the Scottish nation. Prior to 1707 most of Scotland's trade and connections had been with the Low Countries and with France rather than with England. Scotland had always been a poor nation compared with her rich southern neighbour, but with a fierce nationalistic pride. All these varying influences are to be seen in some measure reflected in Scottish arts and crafts. In such matters as architecture these influences are still apparent, showing more affinity with the Low Countries or with France than with England.

The distinction between art and crafts is often a fine one, for inevitably the product of the skilled craftsman in any field is likely to be a thing of beauty

5

in itself. By definition, however, the craftsman is primarily engaged in producing something of use as well as of beauty—an article which can be of practical value as well as admired. Both craftsman and artist may be equally dedicated professionals, each a tradesman in his own way, but in essence the craftsman is engaged in producing an article of utility rather than a pure work of art. Here lies the final distinction between the craftsman and the artist.

In this book an attempt has been made to introduce the reader to those crafts which are generally thought of as essentially Scottish and to indicate their origins, their history and their development. In some instances what started as a craft has developed into an industry with mechanised production on a large scale and sadly few of the old skills remain. An instance of this is the handmaking of golf clubs, once an exclusively Scottish craft now superseded by the introduction of mass-produced steel-shafted clubs. In such cases some indication of what has been lost has been given, but in general there are still craftsmen with the old traditional skills to be found in most fields.

Contents

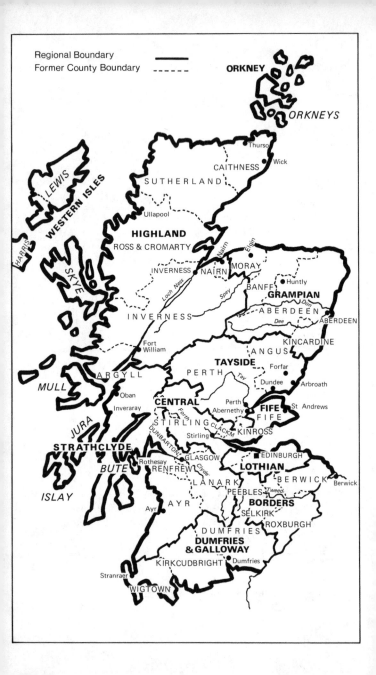

Regional Boundary
Former County Boundary

ORKNEY

ORKNEYS

Thurso
Wick
CAITHNESS

LEWIS

WESTERN ISLES

SUTHERLAND

Ullapool

HARRIS

HIGHLAND
ROSS & CROMARTY

SKYE

INVERNESS NAIRN

Nairn

Elgin
MORAY

BANFF

GRAMPIAN

Don
ABERDEEN

Loch Ness

Spey

INVERNESS

Dee ABERDEEN

Fort
William

KINCARDINE

MULL

ANGUS

TAYSIDE

PERTH

Forfar

Tay

Dundee Arbroath

ARGYLL

Oban

Inveraray

CENTRAL

Perth
Abernethy

FIFE
FIFE St Andrews

JURA

STIRLING

CLACK'N
KINROSS

Stirling

STRATHCLYDE

BUTE

DUNBARTON

Forth

GLASGOW

EDINBURGH

Rothesay RENFREW

Clyde

LOTHIAN

BERWICK Berwick

ISLAY

LANARK

PEEBLES *Tweed*

Ayr

AYR

BORDERS

SELKIRK

ROXBURGH

DUMFRIES

**DUMFRIES
& GALLOWAY**

Stranraer

KIRKCUDBRIGHT Dumfries

WIGTOWN

Tartans, Textiles and Associated Crafts

Tartans and the Kilt

Although today tartans are associated with Scotland throughout the world as closely as Scotch whisky and tweed there is regrettably little reliable information concerning them prior to the end of the 18th century. The Gaelic word for tartan is *breacan,* but the very word tartan itself is not of Scots origin. It is thought to be derived from the French *tiretaine,* which can be translated as 'linsey-woolsey', a type of coarse woollen cloth. It must be remembered, as well, that sheep were very scarce throughout most of the Highlands until the 18th century, since they were easily lost, or stolen, in the hills; and due largely to poor management and lack of sound husbandry it was not thought they could survive the severe Highland winters. Before then, hides or linen were the principal garb of the Highlanders and woollen garments were regarded as a luxury worn mainly by the chiefs of the clans. Thus the development of the clan tartans as they are known now is of comparatively recent origin.

One of the earliest references to what appears to have been tartan is contained in a 13th century Statute of the Church of Aberdeen recommending ecclesiastics to refrain from wearing 'red, green and striped clothing', adding a rider that 'their garments shall not be shorter than the middle of the leg'. From this it would sound very much as if they had been in the habit of wearing the kilt at this early stage, but it must be borne in mind that the dress of the period was somewhat similar to the kilt in any event. It may

even be that around this time both tartan and the kilt, or similar garments, were common throughout Scotland.

Remarkably little was written about tartan, or about Scottish dress, over the centuries. Amongst the earliest definite references to tartan as such is a mention in the royal accounts of James V for 1538 of the purchase of three ells of 'heland tertane' as 'hoiss for the Kingis Grace', or in other words as trews for the King. At this time and indeed until well into the 18th century after General Wade had built his military roads through the Highlands in the 1730s, the Highlands remained virtually cut off from the rest of Scotland. Few visitors penetrated into the trackless mountainous regions and descriptions of the Highlander's garments are infrequent and vague in the extreme.

One of the earliest travellers from England to visit the Highlands was John Taylor in 1618 and in his *Pennyless Pilgrimage* he recorded his impressions as follows: 'the houses of the gentry are like castles, and the master of the house's beaver is his blue bonnet; he will wear no shirts but that of the flax that grows on his own ground, or of his wife's, daughters', or servants' spinning; his hose, stockings and jerkins are made of his own sheep's wool'.

Until the end of the 17th century and well into the 18th century the craft of weaving linen from flax was one of the principal home occupations throughout Scotland. At that time it was thought impossible to make woollen cloth superior to that made in England, but the linen produced was far finer. To encourage this manufacture an Act was passed in 1686 enforcing burial in 'Scots linen'. A reversal of this policy following the Union in 1707 resulted in an Act decreeing that 'no corpse shall be buried in

linen . . . plain woollen cloth . . . shall only be made use of'. The swing to woollen cloth weaving had begun, and although fine linen and damask continued to be woven in Dunfermline until late into the 19th century, from then onwards the weaving of woollen cloth began to take precedence over that of linen. The introduction of power looms by 1800 resulted in the end of what had been a widespread cottage industry throughout Scotland, particularly in Aberdeenshire and the West. Yet during the same period the increase in the weaving of woollen cloth and tartans in particular seems to have been notable.

One of the first references to the wearing of different tartans in different areas is to be found in Martin Martin's *Description of the Western Isles of Scotland* written about 1695. In this he recorded: 'The Plad wore only by Men, is made of fine Wool, the Thred as fine as can be made of that kind; it consists of divers Colours. . . . Every Isle differs from each other . . . thro the main Land of the Highlands, in-so-far that they who have seen these Places, are able at the first View of a Man's Plad, to guess the place of his Residence . . .' This is the first reference to the different *setts,* or patterns, of tartans in different localities and the first indication that clan tartans varied distinctively from each other.

With the Union of the Parliaments in 1707 and the opening up of trade with England surprisingly enough tartan plaids were amongst the first objects to be exported to England, as was noted in the survey entitled *The Present State of Scotland* in 1711:

'In this place it's proper to mention their Plaids, a Manufacture wherein they exceed all Nations, both as to Colour and Fineness. They have of late been pretty much fancied in England, and are very ornamental as well as durable for Beds, Hangings,

Window-Curtains, Night-Gowns for Men and Women: so that attempts have been made in England to resemble them, at Norwich and elsewhere, but they fall much short, both in Colour, Fineness and Workmanship, as is evident at first sight. . . . The stronger part of those Plaids is the usual Cloathing for their Men in the Highlands. . . .'

At this period the weaving of tartan cloth was common in towns adjacent to the Highlands, particularly Stirling, long famed as a tartan weaving centre. It was from such sources also that much of the raw wool used in the Highland glens was obtained, for there weaving tartan cloth had become an accepted part of the woman's work. Sorting the wool, dyeing, spinning and weaving was a natural part of the day to day activities, though highly skilled. The wool would be washed, hand-picked and teased, then carded before being spun on the wheel. The yarn was then transferred to a hank-reel, by which the necessary amount required for a given amount of cloth could be estimated. Then the yarn was wound into balls for the warping-frame and the loom prior to being woven.

Tweeds

Plain woollen fabric, known as *tweels*, was also woven, though more commonly in the south of Scotland, especially in the Borders. It is said that the world-famous name of tweed arose from the mistake made by a Mr. James Locke, a merchant in London, who had received a quantity of tweels from Messrs William Watson of Hawick. The word was written indifferently in the invoice and was read as tweeds. Knowing of the River Tweed in the Borders from the works of Sir Walter Scott, Mr. Locke duly

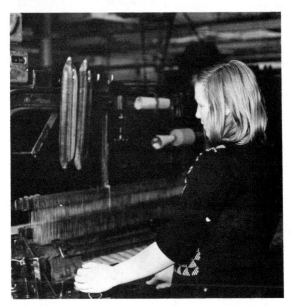

above Weaving

ordered a further supply of tweeds. Today Scotland is as famous for its tweeds as for its tartans. Those woven in the Borders and in the Western Isles, amongst the latter notably Harris tweed, are understandably world famed.

Sheep were scarcely to be found in the greater part of the Highlands prior to their introduction in Ross-shire by Admiral Sir John Lockhart, a Lowlander, in 1762. It is noteworthy, however, that Dr. James Anderson commented on the native sheep to be found in the Hebrides and Western Highlands in 1785 as having 'a peculiarly silky softness and elasticity that is not to be equalled by any other wool known in Europe' and that the breed of sheep 'could easily be preserved without debasement'. It was such wool and such craftsmanship that produced the plaids and tartans in 1711 which could not be imitated by

the finest Norwich weavers of the day and which still makes Scottish tweed and woollen cloths, including tartans, outstanding.

Tartan and Tweed weaving

The difference between tartan and tweed weaving is simply that the yarn with which the tartan is woven is of one solid colour, whereas in weaving tweed the colour is blended during carding, producing a mixture of colours in the yarn itself. Originally, prior to the 1830s, the tweels produced were of drab greys and blues only. The development of tweed as it is known today was effected by twisting together two or more yarns of different colour. With this and Mr. Locke's mistake in the name in the same decade the craft of tweed weaving grew rapidly into a major industry.

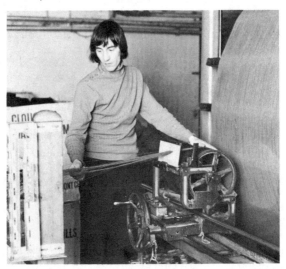

above Carding

Although tweed is still hand woven and remains a skilled craft the effects achieved in the weaving of tartan are the result of even more highly skilled weaving. Exact records of the patterns were kept on special 'warping-sticks' on which the number and order of the threads of each colour in both warp and weft were marked. Thus the exactly similar pattern could be reproduced as and when required.

The dyeing was another skilled process, using purely vegetable sources. Green was obtained from broom or whin-bark. Yellow was obtained from bracken and blue from blaeberries, alum and club moss. Various lichens and seaweeds also produced remarkably delicate hues no longer obtainable with the much harsher synthetic dyes employed today. Understandably local vegetation tended to produce different effects in each different area, hence the origins of many local tartans. It is understandable therefore that anyone travelling through the Highlands would be able to distinguish where a tartan originated.

Highland Dress

As woollen cloth became more widely used in the Highlands during the 17th and 18th centuries so the Highland dress evolved. The basic Highland dress consisted at first of the *leine croich*, or saffron coloured shirt, a kilted shirt with long sleeves and pleats, which required something like twenty-four yards of cloth. It was from this kilted shirt that the later *feileadh beg*, also termed more casually the *philibeg*, or short kilt, evolved. In addition to the leine croich, trews were also worn in wintertime. These were a garment like tight fitting trousers with the foot

inclusive; more perhaps akin to tights than trousers. On top of the leine croich there might also be worn a jacket with sleeves and over all a *feileadh*, or wool mantle, or plaid.

The feileadh varied in size from about sixteen to eighteen feet of double width cloth. It was folded in pleats and buckled round the waist with a wide belt, part was worn kilted round the body and the remainder over the shoulder as a cloak. A tartan feileadh might be worn in this fashion with hose, of contrasting tartan, tied below the knee. A jacket of yet further contrasting tartan and trews of similar or contrasting tartan might also be worn. The results could sometimes be startling in the extreme. Defoe, writing in the late 18th century, referred to a body of Highlanders as looking 'when drawn out, like a regiment of merry-andrews ready for Bartholomew Fair'.

In the 18th century the feileadh, or belted plaid, was shortened and the feileadh beg, or short kilt, was developed in very similar form to that known today. This seems generally to have been worn with hose of contrasting check, but apparently could also be worn with trews, or with a plaid. The variations at this stage seem to have been as infinite as the variations in the tartans themselves, depending largely on the wearer's fancy and the patterns woven locally. With hand weaving and primitive dyeing methods no two cloths were likely to be exactly identical and local variations must have been considerable.

It is a basic misconception that the tartans ever had anything in common with heraldry, which adhered to fixed principals relating to specific families and crests. They evolved locally and generally had only vague family connections. Tartans reflected the Celt's feeling for the glens and the countryside in which he

lived and any tribal or family connection was incidental.

Following the rebellion of 1745, stringent Disarming Acts were introduced in 1746 forbidding the wearing of any form of tartan, or of the kilt, as well as the carrying of weapons. It was not until 1782 that these Acts were finally repealed. In the interval the only opportunity of wearing Highland dress for the Highlander lay in joining one of the Highland regiments, and it is significant that between 1745 and 1815 no less than eighty-six Highland regiments were raised. Initially in these regiments the uniform consisted of the *breacan an feileadh*, or 'belted-plaid' as it was termed in Regimental Orders. This was twelve yards of tartan cloth which served as full dress, overcoat, blanket and groundsheet. In addition a short jacket and hose were also provided.

The intensity of feeling both for their tartans and for the kilt amongst the Highlanders can best be gauged from the following proclamation which was posted in the Highlands on the repeal of the Disarming Acts in 1782. Translated from the Gaelic it reads:

'Listen Men!

This is bringing before all the sons of Gael that the King and Parliament of Britain have for ever abolished the Act against the Highland Dress that came down to the Clans from the beginning of the world to the year 1746. This must bring great joy to every Highland heart. You are no longer bound down to the unmanly dress of the Lowlanders. This is declaring to every man, young and old, simple and gentle, that they may after this put on and wear the trews, the little kilt, the doublet and hose, along with the tartan kilt, without fear of the laws of the land, or the spite of enemies.'

During the period from 1746 to 1816 the kilt as worn by the Highland regiments underwent some considerable changes, chiefly as the result of economies enforced by the authorities in Whitehall. It was, for instance, soon appreciated that the philibeg required less cloth than the full belted-plaid. By dint of providing less cloth the changeover to the short kilt was thus achieved without much difficulty. By 1816 Sergeant Anton of the Black Watch on their return from the battlefield of Waterloo referred caustically to their re-equipping 'in what is generally called the Highland costume' in Edinburgh as follows:

'Here we were served with plaids, purses and buckles for our shoes. . . . The plaid now consists of a yard and a quarter of tartan, a useless shred of cloth, like a child's pinafore, reversed and pinned at the back of the shoulder. . . . The buckle is for glittering show, not use, for it is merely tied on by the shoe-strings, not as a fastening for the shoe. . . . The purse may be considered some decent use, as a sort of apron to keep the kilt properly suspended in front.'

It was Sir Walter Scott as much as anyone who popularised the romantic image of the Highlander and the clan tartans. He was responsible for managing George IV's visit to Edinburgh in 1822, when that city had the opportunity of seeing the king wearing a kilt and full Highland regalia complete with pink silk tights! It was not until Queen Victoria settled in Balmoral and Prince Albert invented the 'Balmoral' tartan, however, that the full seal was set on the kilt as the national dress of Scotland.

During the Victorian era with the 'Balmoralisation' of the Highlands and ever increasing numbers of Englishmen acquiring Highland estates

by marriage or purchase, the wearing of the kilt and the 'correct' tartan became the fashion. Osgood Mackenzie in his book *A Hundred Years in the Highlands* referred to an English 'laird' who bought an estate in the Western Highlands in the 1830s and wore the kilt complete 'with all the paraphernalia of powder horn, and pistols, dirks and daggers'. He wrote: 'at the first Inverness gathering which he attended . . . soon after his arrival from England, he wore one so long that it reached nearly down to his ankles! Some friends having ventured to hint that the kilt would have been more becoming to his figure had it been shorter, he had another made for the Stornoway ball which reached down a very short distance to the great consternation and scandal of the assembled company.'

The rigidity of the Victorian English outlook even extended to the wearing of the kilt. Basing their ideas on the elaborate setts for dress, undress and hunting introduced in the second quarter of the 19th century, they developed a series of elaborate myths concerning the 'correct' wearing of the kilt and the belts, sporrans, *skean dhus* or *sgian dubhs* (the Gaelic spelling), dirks, plaids, bonnets and other accoutrements that go with it.* It was even held to be 'incorrect' to wear the kilt south of the Highland Line, although this, itself, was merely an arbitrary boundary introduced in the 18th century by the southern Parliament for easier tax enforcement.

District Checks

One of the better introductions of the Victorian era was the development of the district check, based on the Shepherd Check, the black and white plaids

* Dealt with in subsequent chapters.

worn by the Border shepherds who drove their flocks each year to the Highlands. The first of these, directly inspired by the black and white pattern, was the Glenurquhart check designed about 1840. Soon afterwards Prince Albert followed suit and designed the Balmoral check, a dark blue and white ground speckled with red. Others, such as the Glenfeshie check, may seem loud out of their own background, but can be seen to merge with their natural surroundings most effectively. These tweeds, originally designed for gamekeepers and similar Highland estate employees, have since developed into an important aspect of Scottish tweed manufacture.

The origins of Modern Tartans

During the enforcement of the Disarming Acts, as there was little or no weaving of tartan, many of the old tally sticks were broken or lost and all traces of the old designs. Along with the considerable local variations in dyes it is not surprising that when the weaving of tartan started again the results were not the same.

Once the systematic presentation of tartans relating to clans started in the second quarter of the 19th century, the results bore little or no relation to the old tartans. This can be seen by comparing almost any modern tartan with those found in portraits of the 17th and 18th centuries.

Most modern tartans, therefore, have a history of only 150 years, although some of the regimental tartans date back over 250 years. An example is the Black Watch tartan, and it is interesting to note that there are at least three clans which claim the Black Watch as their own undress tartan.

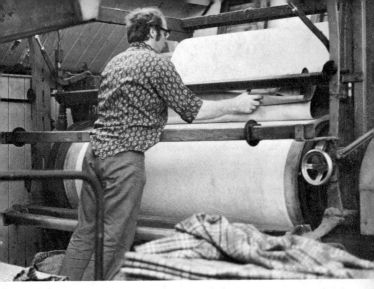

above Finishing Process

The Kilt today

Scottish tartans have been heavily commercialised at times, but they have been evolving steadily over the centuries. They are now reasonably clearly classified and are as much an accepted aspect of national life as the kilt has become the accepted national dress. The introduction of muted patterns in the past fifty years, and even the introduction of entirely new tartans, should be accepted as reasonable and logical. It is even likely that many of these muted patterns are nearer to the true originals, now long lost, which resulted from the use of softer vegetable dyes. To weave any tartan, either new or old, is a task for the craftsman at the loom.

As late as the 1930s there still remained a nucleus of handloom weavers in the village of Kilbarchan, now a suburb of Glasgow. Even now there are individuals who systematically weave the clan tartans in the old

manner. Small mills producing both tweeds and tartans are to be found in various parts of the country, from the Borders to the Highlands, able and willing to produce any required tartan to order. The skills and knowledge required have often been passed down through several generations.

Making the kilt itself is a craft as well. The modern short kilt requires some nine yards of material for a grown man and correct fitting and measurement is essential for the good set of the garment. Many of the Scots kiltmakers have learned their craft over several generations in the same family. There are small kiltmakers to be found in almost every town in the Highlands and many other parts of Scotland.

With a proud martial history behind it, the kilt has, for a long time, been accepted as the national dress. Warm in winter and cool in summer, the kilt is one of the most comfortable and practical garments for a male that can be worn. Although historically there are precedents for wearing tartan tights under the kilt, a Frenchwoman, during the Napoleonic Wars named the Highlanders, 'Les Sans Cullottes', for it is thus it should be worn.

As long as there are craftsmen weavers skilled enough to produce the tartan required, then Scots may continue to wear the kilt with pride.

Paisley Shawls

Two other aspects of 19th century textile work in Scotland merit attention, first, the work of the Paisley shawl makers, a craft industry of considerable importance in Victorian days. With the defeat of the French in the eastern Mediterranean during the Napoleonic Wars in 1801, British trade in Turkish and Indian carpets and shawls greatly increased.

Amongst the most popular of the latter were the delicate designs and soft wool of the Kashmir shawls. These were regarded as a challenge by the Paisley craftsmen already noted for their skills in fine silk and muslin work. By 1820 they had mastered the designs and work and until the 1870s they were famed for their fine 'Paisley pattern' shawls, their yearly output being valued at a million pounds.

The designs were varied, but principally based on the conventional 'pine-cone' fertility symbol of Eastern art. The patterns were a fine intermingling of warm colours with the pine-cone pattern generally dominating the design, though sometimes barely recognisable as such. In some of the very finest of the shawls the centre was left unornamented in a basic colour, then the pine-cone might be found on the corners, but it was generally present.

The weaver, though not working in his home, generally owned his own loom and was paid by piece work, rather than on a wage rate. The conditions, and the pleasant rural setting of Paisley, encouraged the best from each craftsmen. Their designs reflected this and it was only the change in fashion which decreed an end to shawl wearing and the introduction of cotton in place of wool that put an end to their craft in the latter decades of the 19th century.

Hand knitting

Scotland is famous for its fine knitwear and although hand knitting has largely been industrialised today, a great deal of craftsmanship goes into the production of good Scottish knitwear. The Borders especially are famed for their knitwear as well as their tweeds, but this, like tweed weaving, is to be found in all

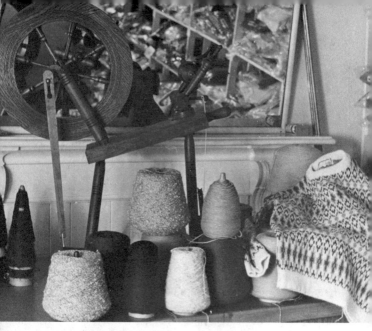

above Wools and Yarns and an example of Fair Isle

parts of the country. Such names as Braemar, Kilspindie, Pringle and Tulloch are household words around the world.

In such well known patterns as Fair Isle and Shetland, now reproduced throughout Scotland, the Scandinavian influence which dominated the eastern islands for centuries is still apparent. The intricate designs once woven only by the crofter fishermen's families on Fair Isle and the Orkney and Shetland Islands have a distinct affinity with Scandinavian patterns.

Ayrshire needlework

The other 19th century craft which merits attention is that of Ayrshire needlework, at one time famous throughout the country. Better known perhaps as

broderie anglaise this was, strictly speaking, a craft of the 18th century when the linen itself was also woven in the same village on a handloom. It was a cottage craft, a task for the long winter evenings by the fireside, or at the cottage door in the sunshine of the summer. The neat hand stitching, the classic designs of the motifs embroidered lovingly on the linen were justly famed.

With the spread of machinery by 1800 the handloom weaving of linen from flax, previously a notable cottage industry throughout the west of Scotland, had come to an end. In all too short a time, mass production had begun to affect the standards of needlework, as many women unable to work at the handloom turned to this instead. Patterns were standardised and central collecting points for materials and for the end products were instituted. Cheap rate piecework, speed and standardisation brought an end to this craft. For a time, the commercialised industry flourished, but a slump following the American Civil War in 1857 finally ended it.

Embroidery and Tapestry Weaving

Embroidery is a craft, in the textile field, which still flourishes today, but was particularly notable in the 16th and 17th centuries. In the Middle Ages it is likely that many of the humbler homes would have had simple home-spun hangings while the larger houses relied to a considerable extent on imported French and Flemish tapestries. Due to wear and tear and natural decay virtually none of these have survived.

There are, however, two interesting examples of *appliqué* needlework curtains of the 16th century still

in existence. Like much of the needlework of the period these are said to be the work of Mary, Queen of Scots. The curtains bear the name of their origin, and are known as the Lochleven and Linlithgow curtains. They are very handsome and have richly stylised flower borders. Whether they were the work of Mary or not, it seems likely that they were Scots in origin, even if foreign 'broderers' were employed to work on them.

There are numerous bed valances of the same period or a little later, which are unquestionably Scots. The embroidery is *petit-point* work, executed with coloured silks and wools on coarse linen, or woven canvas backing. The designs on occasion may have been professional, but the work was amateur though skilled. Some of these almost certainly were the work of Mary, such as those at Hardwick Hall in Derbyshire, which date from the period of her imprisonment there. The Murthly Castle panels in the Royal Scottish Museum are another example of similar work.

Both embroidery and tapestry weaving are crafts in which Scots show a high degree of skill. Scottish tapestry weavers have been called on for many state occasions in the years since the Second World War. The practised professionals, however, are not alone in the field, for, as in the days of Mary Queen of Scots, there are still many skilled people carrying on these ancient crafts in their homes. These are not crafts which are likely to be over-commercialised, however, for they cannot be successfully mechanised.

Stonework and Architecture, Lapidary work, Pottery and Glasswork

Stonework and Architecture

Working in stone, whether in the stark slabs of slate of Caithness, in the silver-blue granite of Aberdeenshire, in the white or red sandstone of the south, came naturally to the Scot in a land where wood was generally scarce and stone was plentiful. Although Scots craftsmen shaped the stones over the centuries and became adept at the work, it was Scots history and the Scots climate to a large extent which shaped their architecture.

In a country perennially racked by warfare, by invasion from the south, or by internal strife, most of the lesser houses were merely sod huts, or wooden structures, which might be pulled down or burned at the approach of an invader and as readily rebuilt when all danger had passed. The buildings that were intended to last were built in stone and used as a refuge both from possible enemies and from the weather. Even the churches, the abbeys and the cathedrals show this tendency to regard defence against man or nature as of the first importance with their uncompromising towers and narrow slit windows.

There are few traces left of the Celtic influence on architecture in Scotland, but it is significant that both the remaining Celtic round towers, at Abernethy in Perthshire and Brechin in Angus, are primarily defensive in nature. The Abernethy round tower is a robust affair 74 feet high and 48 feet in circumference, dominating the kirkyard in which it stands sentinel above the Firth of Tay. The Brechin round

tower, now somewhat overshadowed by the neigh-
bouring cathedral, is more typically Celtic, 87 feet in
height, a thin circular pencil of stone. It has Celtic
carving round the doorway some 12 feet above
ground. Crowned with a pointed cap, it is said to
'bend like a willow in high winds'.

A few miles south of Brechin are the ruins of
Restenneth Priory, built originally in A.D. 710 as a
church to St. Peter by the Pictish king Nachtan
Macderile. A transitional Celtic-Norman building,
the original round tower was rebuilt by the Normans
and the impressive remains standing today contain
five different periods, culminating in a 15th century
spire. Particularly notable is the fact that the position
chosen was a powerfully defensive one before
Restenneth Loch, which surrounded it on three sides,
was drained towards the end of the 19th century.
Another notable transitional tower of this nature is to
be seen in the ruins of St. Rule's at St. Andrews in
Fife, where the massive square tower stands above
the ruins of the chancel.

There are still some fine examples of Norman
architecture in Scotland, notably Dunfermline
Abbey, founded in the reign of David I in the 12th
century. The massive nave with its immensely solid
pillars simply ornamented with zigzags or spirals still
projects a remarkably impressive effect of strength
and majesty. Also outstanding is St. Magnus'
Cathedral in Kirkwall, the capital of the Orkneys.
The impression of size in the nave is a tribute to the
skill of the architect and the builders, but, since the
former was a Norwegian and the latter probably
French it hardly qualifies as truly Scots.

A number of minor churches, notably Dalmeny in
Midlothian and Leuchars in Fife, still show consider-

able Norman influence, despite the inevitable
vandalism at the time of the Reformation. Kelso
Abbey was once a fine example of Norman
architecture, but as it lay directly in the path of the
invading forces from the south, only fragments of the
once fine building remain. Constant rebuilding of
other churches and abbeys has tended to produce a
more solid, essentially Scots type of building.

In the early Gothic period during the 13th century
many fine examples of architecture including the
border abbeys of Jedburgh, Dryburgh and Melrose,
as well as Dundrennan in Galloway, and Arbroath
and Elgin Cathedrals in the north-east were all built.
Sadly, these fine examples of the mason's craft were
built only to be ravaged in secular warfare, and after,
allowed to fall down through sheer neglect. The
'Lamp of the North', Elgin Cathedral, safe from the
invaders in the south is a good example. It was
burned in 1390 by Alexander, Earl of Buchan, the
notorious Wolf of Badenoch. Rebuilt in the
following century the Regent Moray stripped the
lead from its roof during the Reformation. Even
then, although allowed to fall into decay, the central
tower did not collapse until 1711. Despite the fact
that its stones were used to build Elgin Academy as
late as 1800 it still remains one of the notable
ecclesiastic ruins of the period in the north.

During the 14th and 15th centuries the constant
ravages of war resulting in as frequent rebuilding
developed a distinctive Scots style of ecclesiastic
architecture. St. Giles' in the High Street of
Edinburgh, three times sacked by the English and, as
many times rebuilt, reflects a multiplicity of styles,
which are yet essentially Scots. At times a functional
severity of line, combined with solidity produces a
fortress-like embattled look.

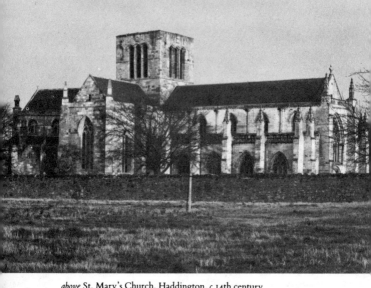

above St. Mary's Church, Haddington, *c* 14th century

Dunkeld Cathedral, built in the 15th century, has a solidly buttressed fort-like tower, but even more plainly Scots is St. Machar's Cathedral in Aberdeen. Built in the early 16th century the machicolated parapet and slit windows give it the appearance of being able to withstand a siege. Its simplicity of style and severity of ornament foreshadow the Reformation, reflecting the outlook of the Scot of the times.

One exception to the generally stark severity of Scottish architecture was the Sinclair Chapel at Rosslyn built in the 15th century, which combines a wild assortment of foreign styles, leaving scarcely a single piece of unworked stone. Despite the strange mixture of styles it manages in some way to be as uncompromisingly Scots as the Castle built into the solid rock lower down the hill, by the same Sinclair family. In their churches and in their war memorials

the Scots have always had a surprising gift for expressing themselves in stone. The solid chunk of native granite bursting through the floor of the chapel in the War Memorial in Edinburgh Castle to the dead of both Great Wars is an inspired example of this particular form of native genius.

The domestic architecture of Scotland has derived its inspiration from the same sources as the ecclesiastical building. The peel towers throughout the Borders and similar high towers elsewhere in Scotland were built as a refuge in time of strife as much as a shelter in time of peace. During the 16th and 17th centuries the lack of timber was expressed in extravagant stone corbelling, with small windows to withstand a harsh climate. The elaboration of these towers is best seen in such examples as that of Claypotts in Angus, where houses seem to have been built perched on the towers themselves, or at Craigievar in Aberdeenshire where the effect is fairy-tale, but purely Scots. In examples such as these the craftsmanship involved in the stone work is quite outstanding.

With a feeling of security and assurance that war and invasion had ceased there was a move to building horizontally rather than vertically, as at the Palace of Holyrood, Falkland and Linlithgow. The desire was for greater living comfort and convenience rather than for defence. The name 'Palace' is derived from the mediaeval term meaning a 'hall'. Thus the Palace at Culross in Fife is in this accepted sense a 'palace', although by modern standards scarcely meriting such a term.

Although the styles of the Low Countries and of France are mirrored in much of the building in Scotland, especially in the coastal belts, the Scots architecture developed in its own unmistakable way.

The 16th century building which took place in Edinburgh and Stirling, after the Reformation, indicates this purely Scots effect of building according to the landscape. The high-fronted town lodgings of the nobles who built in the High Street of Edinburgh along the 'Royal Mile' are the finest example of this vernacular building. The wynds and closes, the perpendicular faces of the buildings, the sharp spiral stairs and numerous other features are purely Scots in origin and effect.

There are many small towns and castles of the same period which deserve notice, but perhaps the finest example is that of the burgh of Culross in Fife. The red pantiled roofs, the tiny wood shuttered windows, the curving streets with their tight cobblestones, the sudden vistas and unexpected turrets, make this one of the most surprising and charming period pieces possible to find. The Palace at Culross, erstwhile home of a merchant, and the numerous other houses of this old Fife port are all worthy of note. Many of the other Fife ports, Anstruther, Elie, Crail are also worthy of a visit. Here the old Scots burgh architecture is seen at its best. There may be Low Country influence in the red pantiled roofs and, in other instances, such as Haddington, the French influence may be plain, but in all the final effect is clearly Scots.

It was with the advent of Scottish classicism that the true Scots vernacular architecture gradually ended. Significantly this was the result of the Union of the Parliaments in 1707 when the Scots nobility moved south and developed a taste for English ideas, although the introduction of alien styles from the south first began to be noticeable after the Restoration in the 1660s. The outstanding example of that period is to be seen in the present frontage of the

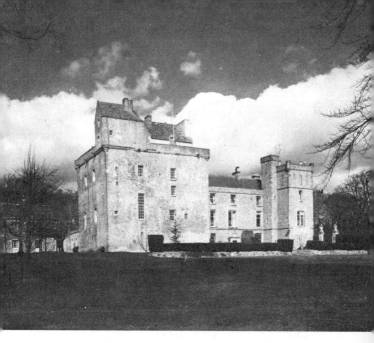

above Lennoxlove, East Lothian

Palace of Holyroodhouse. Charles II's architect, Sir William Ross, 'balanced' the front by building a replica of the existing single turret and joining the two with balustrading across the roofline, an idea, which never really found favour in Scotland, although copied in various Palladian frontages during the late 18th and early 19th centuries.

The neo-classical New Town of Edinburgh, planned and built in the late 18th century under the influence of Robert Adam, is perhaps the finest example of town planning of this period in Scotland, indeed in Britain. Princes Street has become famous rather through its magnificent position than through its architecture, which has been bastardised in the worst possible manner today. The broad sweep of George Street, named after George III, and the

splendid terraces at the west end, built in the early 19th century remain a fine example of neo-Classical planning and architecture. This was a style which developed in Scotland until well into the 19th century, before being gradually swamped in the neo-Gothic Scots baronial of the Victorian era. The many examples of this later style, abounding in pepper-pot towers, crow-stepped gables and Gothic windows are best overlooked, although, unfortunately, built in granite by craftsmen skilled in the mason's craft they still stand as a witness to the solidity of their work as well as to the atrociousness of the architect's design.

Brochs

In the Highlands the art of building in stone without the use of cement is amongst the oldest crafts of all. The prehistoric brochs, such as that in Strath More beneath the towering slopes of Ben Hope in Sutherland, are a good example of this craft. According to a 19th century Gazetteer: 'the famous tower, Dun Doroghil . . . has been constructed without any cement. . . . It is built in a circular form, tapering outside like a sugar loaf, externally fifty yards in circumference and twenty-seven feet diameter in the inside. . . . The wall in some places is nearly thirty feet high.' It still stands as a monument to the work of its prehistoric builders.

Dry stone dykes

The countless miles of dry stone dykes with which the Highlands and indeed the greater part of Scotland are now criss-crossed and patterned, stand as a monument to much later craftsmen. During the late 18th and a greater part of the 19th centuries the craft

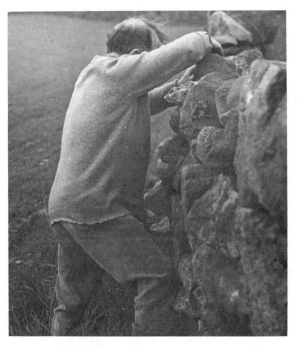

above Dry Stone Dyker

of stonemason was amongst the commonest followed
by young Highlanders. It was during these years that
the craft of dry stone dyking became of real
importance when the consciousness of land boun-
daries, especially in the Highlands, first began to be a
matter for concern and when sheep or cattle had to
be restrained from straying. The skill and labour
involved in building a wall with boulders weighing
several hundredweight apiece at the base and lesser
stones neatly built up above them to form a solid
barrier at a level 4 feet 6 inches high is considerable.

Such a wall must be able to withstand the heavy snows and fierce frosts of winter as well as the efforts of sheep or cattle to surmount it. It says much for the skill and craft of those concerned that many of these walls built well over a century ago are still standing today.

Stones of Strength

In the Highlands from the earliest days the lifting or throwing of stones has been regarded as a test of strength and manhood. The *Clach Cuid Fir*, the Manhood Stone, was a large stone weighing anything from a hundredweight upwards which had to be lifted from the ground and placed on a wall waist high. The sheer difficulty of lifting a round smooth stone from the ground is not easily appreciated by those who have not attempted it, and no doubt these stones proved a useful test of a young man's strength. Such a stone would often be found adjacent to the door of the chief's dwelling, or some convenient public place. The *Clach Neart*, or Stone of Strength, was generally thrown, or putted, as a test of strength and this, of course, was a much smaller stone of some thirty pounds weight, which the contestant would be expected to throw, or put, against another known for his skill and strength. In this way the chieftain could also estimate the strength of his young followers, who no doubt vied with each other in such trials of muscle and sinew.

Such Stones of Strength and Manhood Stones are still to be found throughout the Highlands. There is, for instance, a well-known *Clach Cuid Fir* called the Putbrach outside the kirkyard at Balquhidder. At Inver, a small village near Braemar, there is another well-known Manhood Stone weighing 285 lbs. Two

other noteworthy examples are the Stones of Dee, outside the inn at the Bridge of Potarch, where they were used by travellers for tethering their horses. Together these stones weigh over 785 lbs., but while repairing the bridge in the 1870s they were lifted together by the famous stonemason and athlete Donald Dinnie and carried five yards—a feat well beyond the present weight lifting records!

The Highland Games

With the general Balmoralisation of the Highlands in the 19th century such feats of strength began to be organised into annual contests. These Highland Games, or Gatherings, held in each town and village, soon became widespread throughout the Highlands during the summer months.

Highlanders, including stonemasons and black-smiths, pitted the muscles developed in their crafts against each other in various ways. At first merely an excuse for a local holiday, they developed into a unique tourist attraction. Although a slight digression, they merit consideration.

Putting the stone, either a 16 lb. metal ball over 50 feet or more, or a 28 lb. 'stone' over 30 feet, is still a part of the Games. Throwing a 28 lb. weight with a ring over 70 feet after one full turn is another competition, as is tossing a 56 lb. weight over a bar reaching as high as 14 feet from the ground. Throwing the hammer, an iron spheroid on a wooden shaft weighing 16 lbs. over 130 feet, or 22 lbs. over 100 feet is another sport developed from hurling the hammer outside the village smithy.

Tossing the caber is perhaps amongst the most spectacular of feats at these Games. The test is to toss the caber so that it turns in a direct line from the

thrower. The normal caber is 17 feet 3 inches in length and weighs 91 lbs., generally for local competitors only. For the Open competitions it weighs approximately 114 lbs. At the Braemar Gathering a caber, known as the Braemar Caber, measuring 19 feet 3 inches and weighing 120 lbs. is used.

Pole vaulting is practised with no professional box in which to place the pole and no bed on which to land. Wrestling in the Cumberland style is another attraction, as is the tug-of-war competition between rival teams. More typically Highland, however, are the Pipe Music and Highland Dancing competitions. Finally the Games are brought to a close by the march past of the massed Pipe Bands. These Highland Games, held throughout the Highlands and famous around the world, have come a long way since the original test of manhood, the *Clach Cuid Fir*, but they remain a unique spectacle well worth seeing.

Curling

Another Scots game associated with stones, common to both Highlands and Lowlands, is that of curling. The early game seems to have been a form of quoiting on ice, using a stone rounded by the river, hence the name *channel stone* still given to the curling stone. This would weigh a few pounds with a niche for the thumb on one side and the fingers on the other. With a curving throw or sweep the player would throw his stone on the ice to a mark on the surface. This was known as the Kuting-Stone, or Pilty-Cock period of curling.

This was followed by the Giant or Boulder stage, when the curler took a large boulder from the river

and inserted a rough iron handle in it thus propelling it along the ice to the mark. The variety of weight and shape at this stage seems to have been very considerable. The minimum weight appears to have been 60 lbs., whilst one is known weighing 117 lbs., and stones over 200 lbs. weight were mentioned. Each was shaped according to the owner's fancy and must have appeared a motley collection on the ice.

About mid 18th century, however, the game, in common with much more of Scots origin, was 'improved'. Clubs, including the renowned Canon-mills and the Duddingston, were formed. Finally, in 1838, the Grand Caledonian Curling Club was formed to regulate the game.

The present day curling stones have been fixed at a maximum weight of 44 lbs. with the handle, but the majority of stones are between 35 and 38 lbs. A pair of exactly matched stones are required by each player and they are generally named after the places from which the stone was procured. Ailsa Craig stones, taken from the quarry on the island of that name off the Ayrshire coast, are particularly popular. Craw-fordjohn, Burnock Water, Douglas Water, Crieff, Carsphairn and Tinkerhill are also well known names. The stone is quarried in square chunks and goes to the manufacturers to be rounded and polished. Each stone has two sides, one highly polished and curved for dull ice and the other side for keen ice.

Lapidary work

A comparatively modern innovation is the manufacture of miniature curling stones as lighters, paperweights or similar souvenirs. Indeed, strangely enough the manufacture of jewellery, or lapidary

work in semi-precious stones, is altogether a comparatively recent craft in Scotland, dating back little more than a century and a half. Although no precious stones are found in Scotland, there are still semi-precious stones to be discovered in places. In Aberdeenshire there are cairngorms, agates and beryls, in Ayrshire agates and jaspers, while Perthshire has bloodstones and other varieties of semi-precious stones. There are garnets in Fife and at one time amethysts were also found in Scotland, though now rare. Scotch pearls from mussels are still to be had in places and when well set are most attractive.

Bracelets, necklaces, rings and similar decorative jewellery made from polished native stone, or quartz, can be as attractive as many precious stones. Modern designers have cleverly adapted themselves to the use of the native stones, or semi-precious stones in this way. Lapidary work in polished pebbles and quartz has become a feature of much attractive Scottish craft work today. The use of ancient runic patterns with a cairngorm or imitation cairngorm set amid native polished pebbles is a combination of ancient and modern which can be very pleasing.

The larger plaid brooch inset with semi-precious stones is a form of ornament dating back several centuries, yet retaining an essentially Celtic design. Since the plaid brooches, however, were basically made from metal alone, they are better considered under that heading.*

Pottery

Pottery, in the sense that it comes from clay, may also be allied with stonework, but this is a craft in which Scotland was more backward. Ceramics have always

* Page 86.

been a very minor craft in Scotland with a tendency to follow the lead of other countries. There have been, however, various potteries of note with their own peculiarly Scots styles. Thus the tilery in the 13th century North Berwick convent produced some interesting tiles quite unlike those of England or France, more closely resembling those to be found in Switzerland at the same period. Moulded with animal designs in relief, panthers, lions and dragons, they are good, well-baked tiles with a distinct spirit and style of their own.

Apart from some great earthenware vessels of much the same period, suitable for carrying and storing water or ale, little Scots pottery of any merit has survived the intervening centuries until the end of the 17th century. It was about this same period that Josiah Wedgwood revolutionised English pottery making. The first Scottish pottery established was that at Delftfield near Glasgow in the late 17th century. By the late 1740s the products were considered as good as English pottery, although distinctly derivative. Another pottery in the west was that of J. & M. P. Bell, which achieved considerable success in the late 18th and early 19th centuries. Their trademark was a bell, and they employed Chinese artists to design the patterns they used. The bulk of their products, however, were exported to the Far East.

Surprisingly it was a glassworks, named Verreville, also near Glasgow, which obtained the finest results in the early 19th century on turning to the manufacture of porcelain. They imported potters from the Low Countries and from England and produced a pure china with a fine glaze finish. They became notable for finely modelled figures before the factory finally closed in the 1850s. None of these,

however, could strictly speaking be considered notably Scots in style.

It was in the east of Scotland that a more distinctively Scottish style was achieved. Towards the end of the 17th century a pottery, making tiles, pipes and similar domestic articles was established in Prestonpans. As there was a constant traffic between the Low Countries and the ports of the Forth, it is probable that this had a direct connection with the establishment of this pottery and others around the Firth of Forth. It certainly seems significant that all the potteries in the east were established in ports adjoining the Forth.

The earliest two potteries in Prestonpans were those of Gordon and of Watson. The former produced a creamy white ware with a hint of blue in it and a good glaze. The latter, however, specialised in figures and groups, mostly of local interest. Although English potters were brought in for this work and there is a resemblance to Staffordshire ware, the fishwives and other local subjects are expressive and sensitively finished. Watson also produced punchbowls underglazed in blue and painted with flowers, which at one time were given to incoming farm tenants, but are now extremely rare and of some value.

During the 18th and 19th centuries, Musselburgh, Portobello, Bo'ness and Kircaldy all had individual potteries producing work of various qualities. China dogs, 'wally dugs' as they were affectionately known, punchbowls, groups of figures and similar work were all produced, although few were as fine as the products of the two Prestonpans potteries. Unfortunately, due to the steady influx of cheap pottery from the south the craft of pottery had nearly died out prior to the 1939–45 war.

Since 1945 many individual potters have started their own potteries in Scotland and there has been a steady increase both in the quality and quantity produced. Although much of the pottery produced today is by craftsmen from abroad who have settled in Scotland, there are, also, a considerable and growing number of native Scots turning out work of high merit and fine artistic achievement. In a sense, however, pottery is international and few pieces today could be said to be distinctively Scots. Yet even so there are some potteries turning out ware of high quality which has a distinctly Scottish flavour and style of its own.

Glass

Like Scottish pottery, Scottish glasswork dates effectively from the 17th century. Before then glasswork was not a highly developed craft in England either. In 1610 Sir George Hay received a patent, or monopoly right, from James VI and founded a glass-making factory in Fife near Wemyss. He had a ready supply of coal from the pits inland and sand and seaweed from the shore nearby. He secured the services of both Italian and French craftsmen, who were considered the finest available. Sir Robert Mansell who had the monopoly patent for glassmaking in England accused his Scots rival of bribing his craftsmen to move north. Despite this, it seems as though the English factory produced better work, since a Royal Commission in Scotland advised using the English work as a standard pattern. In any event Mansell eventually gained control of the Scots works on Hay's death.

Due to the bond between the Low Countries and the Forth ports, it was not long before William

Morrison of Prestonpans had developed a manufactory of 'hand keiking glasses', or hand mirrors, which the Flemish workmen were expert at producing. Morrison seems to have improved on their methods of using a tin backing by adopting an amalgam of mercury. He was soon also producing other Flemish glassware and he was not alone in following the example set in Wemyss, despite the patent granted to Sir George Hay.

A glassworks was soon started in Leith capable of making bottle glass, and in 1664 it was noted that it was producing 'all manner of glass-ware'. Verreville, founded in 1770 in the west, near Glasgow, was soon producing a variety of glass from decanters, doorknobs, candlesticks and chandeliers of notable lustre and brilliance to even finer work. A pair of thistle glasses and a decanter illustrated by Fleming in his *Scottish and Jacobite Glass* are outstanding. In general, however, the Scots turned out articles for general use, bottles rather than decanters, tumblers rather than wine glasses. They exported considerable quantities to the U.S.A. and Canada.

Amongst the most interesting of Scottish glassware during the 18th century was the glass produced in defiance of the Hanoverian government for the use of Jacobite sympathisers. Wine glasses of this period frequently have the initials I.R. standing for Jacobus (Iacobus) Rex engraved in such a way that they can be read as G.R., or Georgius Rex. They are sometimes openly engraved with a crown and oak leaves, thistles and similar emblems entwined around. Toasts to the King such as 'Slaunt an Rey' are generally ended with the word 'Amen', hence they are often known simply as 'Amen' glasses.

The Jacobites, both before and after the Rebellions of 1715 and 1745 delighted in secret emblems and

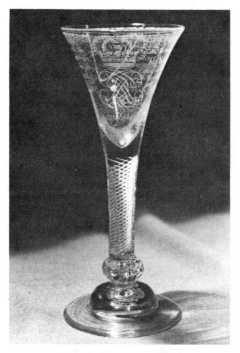

above An Amen Glass, made between 1720 and 1750

code words, supposedly acknowledged and under-
stood only by those sympathetic to the 'Cause'. Oak
leaves, or sprays, were intended to refer to the
Boscobel Oak in which King Charles hid successfully
after the battle of Worcester. A blackbird was
intended to refer to the Old Pretender, James III, and
was a reference common at the time of the 1715
Rebellion, being taken from a song of the day 'Good
luck to my blackbird where'er he may be'.

One of the most frequently used emblems was the
rose of the House of Stewart with the petals
displayed. Two buds on the stem, though probably

merely a part of the design, are often taken to be representing Prince Charles and his brother. Admittedly many of these glasses were of English origin and others were probably made in the Low Countries, but some must also be of Scots manufacture. Where the thistle is prominent it may usually be taken that they have a Scots craftsman behind them. Where portraits of Prince Charles in tartan and bonnet are engraved they too must also have a Scottish origin.

Some of the Jacobite glass with baluster and airtwist stems are of fine proportions and excellent execution. They indicate that the Scottish craftsmen of the day were capable of as good work as any on the Continent or in the south. Unfortunately, in the 19th century with the influence of Scottish Gothic and 'Balmoralisation' of taste effecting every sphere of Scottish life the glasswork too degenerated. Ugly thistles and weird shapes predominated. The craft of glassmaking degenerated until the post-1914 War period when there was a welcome return to better standards.

Since the 1939 War also there has been a welcome injection of new life and fresh ideas in Scottish glassmaking. The work of the Edinburgh Crystal works is well known. In the 1950s the Caithness gassworks was established at Wick by the Sinclair family. Italian master craftsmen were employed to impart their skills to local apprentices and a distinctive style of their own soon appeared. There are other glassworks in the west and there has been a return to high standards of craftsmanship once more. This is notable also in the fine engraving work of a number of individuals, and it can be truly said that Scotland has now reached a high standard in the craft of glassmaking and engraving.

Horn and Woodwork

From the very few examples which have survived today it is clear that as early as the 15th century the Scots were capable of producing some fine wood and horn work richly carved and decorated. Yet, although small trinkets and *objets d'art* must have been common, remarkably few are to be found. A whalebone casket, some ten inches long, known as the Eglinton Casket, is to be seen in the National Museum of Antiquities, and is one of the few examples known. It is bound with metal straps and studs and is finely carved with an intricate interlocking knotted pattern reminiscent of much earlier Celtic carving and designs. Since such caskets are represented on the tomb slabs of various chieftains it is clear that they were once common in the families of the nobility. It is possible that there were other similar small works of art and fine craftsmanship, now unfortunately lost.

Powder horns

The Celtic design which is obvious in such work was carried on in some of the horns, principally powderhorns, which were common in the 17th and 18th centuries. These horns were made by heating and flattening a cow's horn and attaching a metal nozzle, generally of pewter. Intricate carving, or engraving, produced an object of considerable artistic merit.

One of the finest early horns to be seen in the National Museum of Antiquities is associated with Sir George Mackenzie of Tarbat and dated accord-

ingly about the mid-17th century. This has a finely executed hunting scene with two Highlanders and a hound on a leash surveying two stags disappearing into trees. The back is decorated with fine interlocking knotwork. This is an extremely rare example and it is noticeable that in the 18th century, when the use of compasses was employed to achieve the interlacing ornamentation, the work begins to show signs of deterioration.

The various types of horns have been classified in six different varieties: those with decorative cross-bands and 'fan' ornamentation; those with ornamentation or shield enclosed in circles of Celtic type; those combining both these methods of ornamentation; those with thistles, roses and tulips, signifying Scotland, England and Holland; those with a hunting or similar scene and finally an unflattened type usually with ships engraved on them, which it is thought might have been used on board ship. This last type of horn is 18th century and the making of true Highland powder horns seems to have ended with the 17th century.

Dirks

The same Celtic design is to be seen on the hilts of the Highland dirks of the 16th and 17th centuries. Generally made of heather root, these hilts are quite deeply carved with similar runic designs.

It is possible that the original purpose of carving the hilt in this fashion may have been simply to obtain a better grip. The dirk was an all-purpose dagger used as readily for gralloching a deer, and for eating the meat subsequently, or for close combat fighting. The small *skean dhu* or *sgian dubh* worn in the stocking, or concealed beneath the armpit, also

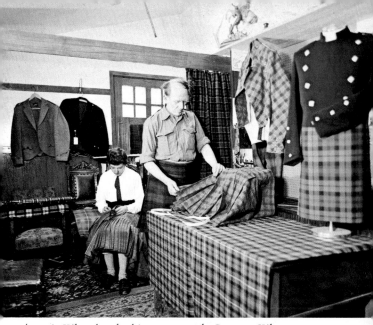

above A Kiltmaker looking at an 18th Century Kilt

below Tapestry Work

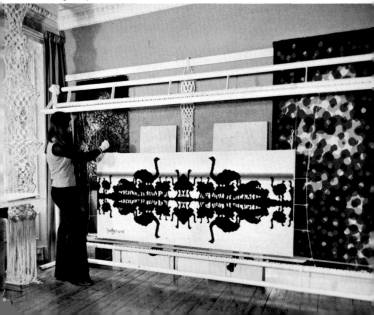

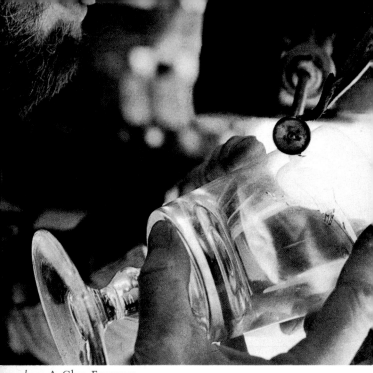

above A Glass Engraver
below Powder Horn, *c* 1670, showing a Hunting Scene

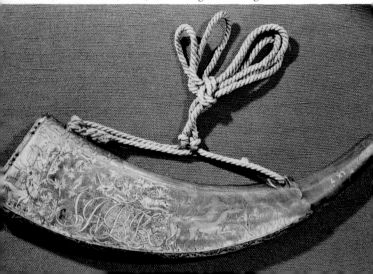

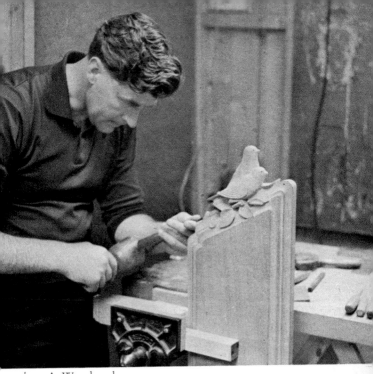

above A Woodworker
below Fishtail Butts dated 1611 and made in Dundee

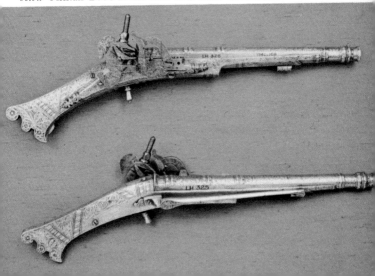

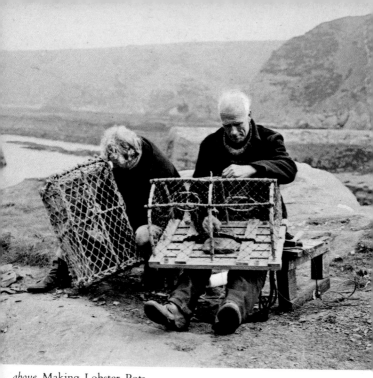

above Making Lobster Pots

below 'Bonnie Prince Charlie's Targe', c 1745, and a Broadsword, c 173

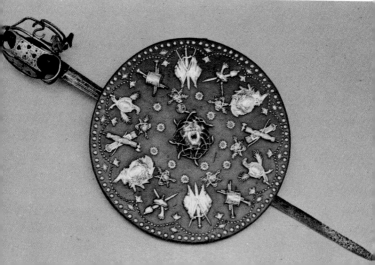

sometimes had a well-carved hilt in the same fashion.

During the 18th century the carving deteriorated and in the 19th century the practice evolved of forming the hilt into a bulky thistle crowned with a large cairngorm. Even the skean dhu or sgian dubh suffered this strange transition.

Crooks

One form of horn carving now common in the Highlands dates from no earlier than the late 18th century. Although the shepherd's crook is an ancient device, older than Christianity itself, it is unlikely that it was common in the Highlands where sheep were scarce. The fashion of carrying a carved *cromach*, or crook, though now prevalent is a Lowland introduction no older than the 18th century. Admittedly today the carving on occasions reaches a high degree of virtuosity and craftsmanship, but this is largely a modern development.

Golf clubs

The theory that the game of golf was originated by a shepherd idly hitting a pebble with his crook is one amongst numerous whimsical and serious suggestions put forward by golf historians. Some writers insist that the game originated in the Low Countries. Others have traced it back to the Romans. It should surely be enough that for over five centuries it has been played keenly in Scotland attaining the status of the national game.

It was certainly common enough in 1457 during the reign of James II to be banned along with football as distracting the citizens from their archery practice! The Scottish Parliament decreed 'that the fute-ball

and golf be utterly cryit down and nocht usit'. It is clear the ban was ignored, for it had to be repeated in 1471 in the reign of James III and again in 1491 when penalties were decreed against players of 'golfe, or uther sik unprofitabill sportis'.

By 1502, however, James IV himself was converted to the game. According to the accounts of the Royal Treasurer he paid fourteen shillings for clubs made by a bow-maker in Sainte Johnstoune, the ancient name for Perth. The ensuing Royal Accounts predictably show entries for supplies of new golf balls, also payment of wagers lost at the game.

Although there are only scanty records during the 16th century, with the growing use of gunpowder the bow-makers, no doubt, found it a useful sideline to their declining craft to turn to making golf clubs as the number of players steadily increased, following the court's example. The royal patronage of the game continued under both James V and his daughter, Mary Queen of Scots, who was criticised for playing golf only a few days after the murder of her husband Darnley. The keenest royal golfer of all, however, was James VI of Scotland and I of England, who first popularised the game in the south.

It was during James VI and I's reign that the import of golf balls from Holland was prohibited on the grounds that: 'No small quantity of gold and silver is transported yearly out of his Hieness Kingdome of Scotland for bying of golf balls.' A certain James Melvill was granted the monopoly of making and selling golf balls. At about the same time one William Mayne also became the first golf club-maker to be granted a Royal Warrant and the first of a long line of craftsmen to be named.

After William Mayne the next prominent club-maker was James Pett of St. Andrews, which was

already recognised as a flourishing centre of the game. In 1627 Pett supplied clubs to James Graham, subsequently the famous Marquis of Montrose, then an undergraduate at St. Andrews' University, but apparently a keen player both there and at Leith. An account of this period reads:

. . . 'Bonker clubs, a irone club and taw play clubs of my awing. For mending bonker club 1s 6d. For a golfe club besydes and payet be my Lord for me and Joe Stephenson and for a club shaft—Joe Forrest—10 shillings.'

Two other notable golf club-makers of the period were Henry Hill of St. Andrews and Andrew Dickson of Leith. It is thought that a set of clubs, woods and irons, now to be seen in Troon Golf Club may be of this period, possibly the work of Mayne or Dickson. The discovery of these clubs was quite astonishing. They were found in a house in Hull which was being demolished at the beginning of the 1900s. They are among the oldest clubs still preserved and certainly date from the days of the Stuarts.

Some idea of the development of the craft of making clubs and balls towards the end of the 17th century is conveyed by a letter dated 27th April, 1691, from Professor Alexander Munro to a friend, John Mackenzie in Edinburgh, which reads in part:

'Sir, Receive from the bearer, our post, one sett of Golfe Clubs, consisting of three, viz: ane play-club, ane scraper, and ane tin-faced club. I might have made the set to consist of more, but I know not of your play, and if you stand in need of more I think you should call for them from me. Tho I know you may be served there, yet I presumed that such a present from this place, the Metropolis of Golfing may not be unsuitable for these fields, especially when it comes from a friend. Upon the same

consideration I have so sent you ane dozen Golfe balls, which receive with the clubs. I am told they are good, but will prove according to your play and the fields. If the size do not suit, were you so free with me, I would send it with the next. I am . . . Al. Munro.
P.S. The bearer may have other clubs and balls from this place, but yours cannot be mistaken if you received them marked, viz: the clubs with the letters G.M. as the tradesman's proper signe for himself, and J.M.K. for your mark stamped upon ilke ane of them. The balls are marked W.B. which are not ordinarily counterfeited.'

Already it is clear that St. Andrews had become established as the centre of golf, although the game was being increasingly played elsewhere, even as far south as Blackheath, where it had been introduced by James VI and I. Throughout the 18th century St. Andrews continued to be famed both for its clubs and balls. Originally the balls had been of wood, or flock, tightly bound with leather, but in the 1770s when Pennant, who was clearly no golfer, visited the city during his *Tour of Scotland*, he noted:

'The manufactures . . . are . . . that of golf balls; which, trifling as it may seem, maintains several people. The trade is commonly fatal to the artists, for the balls are made by stuffing a great quantity of feathers into a leathern case, by help of an iron rod, with a wooden handle, pressed against the breast, which seldom fails to bring on a consumption.'

In the 1770s James McEwan, a carpenter by trade, started manufacturing golf clubs in Leith, convenient to Edinburgh. The family became noted at the craft and his grandson, Douglas McEwan, was famous throughout a large part of the 19th century, both in Leith and Musselburgh. In St. Andrews during the

first half of the century the most noted club-maker was named Hugh Philp. Both he and McEwan were experts in making wooden clubs, using thorn for the heads and ash spliced into the heads for shafts. Apple, pear and other indigenous hardwoods were also used for the heads as the century progressed.

Throughout the first half of the 19th century the 'featheries', as the balls were called, continued to be made in the manner described by Pennant; traditionally they were stuffed with a top hat full of feathers, then stitched up and hammered until spherical and approximately $1\frac{1}{4}$ inches in diameter. Painted with white oil to make them waterproof and readily visible, they were remarkably tough and elastic. The record drive with one is stated to have been 361 yards.

It was not until the late 1840s that they were superseded by the gutta-percha ball. In 1843 Dr. Paterson of St. Andrews University received a package from the Far East encased for safety in gutta-percha. His son Robert discovered that suitably rolled and compressed this made a good cheap golf ball. In 1846 this was marketed as the Paterson Composite Golf Ball, and in a short time several varieties were on the market. It was not until around 1900 that rubber cored balls with merely a coating of gutta-percha were introduced, but by this time their manufacture had become an industry rather than a craft.

When the St. Andrews club-maker Philp died in 1856 he was succeeded by his nephew Robert Forgan, who was to become one of the famous names in golf club-making, the founder of a dynasty. It was he who introduced the use of hickory shafts and the principle of securing the bone to the base of wooden clubs with pegs driven in at a slant. Up until this time a set

of all wood clubs might still consist of the following: a play club, or tee-club (or driver), a long spoon (or brassey), a mid-spoon, a short spoon, a baffling spoon, a driving putter and a wooden putter.

In addition a rutting iron, or sand iron, might be carried which was only used to play a ball when it lay so badly that using a wooden club might result in breaking the head or shaft. The old Scots word *cleek*, meaning a hook, was applied to any such iron club in the early days, because, in effect, the player hooked, or 'cleekit', the ball out of the rut. It was Allan Robertson, appointed first professional of St. Andrews in 1858, who started to use his cleek for approach shots to the green. Soon the local blacksmiths, notably Robert Wilson, were turning to 'cleek making', or forging 'fine, clean cleeks'. It was not long before the 'cleek' or iron club-makers had begun to develop their art quite separately from the wooden club-makers.

Within a decade or so the introduction of the new gutta-percha ball had revolutionised the game. Soon the faces of the iron clubs were being skilfully forged as *mashies*, *mashie-niblicks* and *niblicks* in order to obtain better control. The game had begun to change radically and the craft of golf club-making with it. Familiar names such as Tom Morris, Anderson and Auchterlonie, as well as Forgan, in St. Andrews, Simpson in Carnoustie, Scott in Elie, Sayers in North Berwick, to mention only some of the leading club-makers were soon vieing with each other. The notable cleek-makers, who specialised in iron clubs during those early days, were Condie and Stewart in St. Andrews and Nicoll in Leven, forging each club head by hand.

Golf club making continued to be a craft of

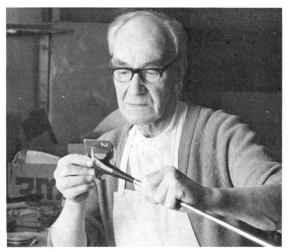

above Golf Club-maker

considerable importance in Scotland until the 1920s,
by which time mass production had begun to appear.
Many of the old names continued in business, even if
the old distinction between wooden club-makers and
iron club-makers had long disappeared. It was the
introduction of the steel-shafted clubs in 1929 that
finally spelled the end of the individual craftsmen and
the beginning of mass production. Of all the names
mentioned, only Ben Sayers of North Berwick and
Nicoll of Leven are in business today and of those
two, only Nicoll remains a family firm.

Shinty sticks

As there were once craftsmen who took a pride in
making golf clubs by hand so there were also
craftsmen who produced shinty sticks for the

essentially Celtic game of shinty. It is still played in the Highlands and in Ireland, but is restricted more or less exclusively to these areas. A wild and keenly contested ball game played with curved sticks between two teams of twelve members a side, shinty is somewhat akin to hockey and sometimes more akin to war! The sticks themselves are now mass produced, but the game appears to be an interesting example of native survival.

Furniture

Much that was once native to Scotland was swamped after the Union and amongst the crafts most affected were wood-carving and furniture making. Unfortunately there remain few traces of good Scottish wood-carving since much of it necessarily was ecclesiastical and suffered either by neglect or by defacement or even destruction with the reform of the Kirk. Around the late 15th and early 16th centuries, however, a certain distinctive Scottish style of carving emerged, which was distinct from the French and Flemish of the same period. It is perhaps significant just the same that almost all the wood-carving of this period originates on the east coast where there was ready communication with the Continent. Perhaps the finest example of Scottish style around this period are the Montrose Panels in the Scottish Museum of Antiquities, dating from around 1516. They have an individuality and power, delicacy and wit of great merit, which is not easily matched.

In general, however, the Scottish style was cruder than the English and Continental styles, full of vigour, but lacking fine execution. An example of this, again in the National Museum of Antiquities, is

a door from Amisfield Tower, dated 1600. On it is a carved representation of Samson slaying the lion. Robust and vigorous, but ill proportioned and crude to the point of grotesqueness, it depicts a large Samson clad in the dress of the period, with pony-tail hair-style, dealing with a puny-limbed lion about the size of a large pet dog.

Other examples are to be found between the two already mentioned, where the effect is pleasing but the carving itself is crudely finished. Almost certainly the lack of trees, especially the lack of oaks, was one of the basic reasons for the lack of good carving in Scotland. As is clearly indicated in examples of the stone-carving of the same period the Scots were not lacking in artistic ability or sensitivity. It was in stone, rather than in wood, that their work found its full expression, principally because the basic materials were readily to hand in the one case and lacking in the other.

To some extent the same reason may lie behind the lack of any really fine Scots style of furniture. Little is known about Scots furniture prior to the 16th century. The typical mediaeval furniture probably consisted of a high table, possibly just a thick plank raised on trestles, and a high-backed chair, plain or carved, similar to that common in England at the same period. Plain aumries, or cupboards, for storing linen, plates and similar household effects were also common.

During the 16th and 17th centuries the table developed into a more substantial affair with turned solid legs. A form of draw table, with sliding leaves, was developed, but was more common in England. It was only in the chairs that something approaching an individual Scottish style developed. The back is solid, often carved, and the seat plain wood. There are

generally arms, either curved or splayed. The back legs are generally square and undecorated, but the front are usually turned and may be decorated with carving. They are often joined by plain wooden stretchers.

The wall cabinets and beds were generally imported and in the Scots house it must be remembered that tapestries and hangings generally concealed much. It was in the Scots character to produce a good appearance and this was achieved by hangings and coverings of this nature. Thus when the Union came in 1707 there was scarcely any native style to withstand the English styles of furniture. Sheraton and Hepplewhite, and Chippendale were copied slavishly, although frequently with an unusual touch, such as the chairs in laburnum wood to be seen in Blair Castle.

Orkney chairs

Only one native style persisted and that was the Orkney chair. This primitive chair form is simple and surprisingly comfortable. They were found originally, in various sizes, in the houses of the crofters and fishermen on the Isles of Orkney. Today they are being manufactured by skilled Orkney craftsmen once more. The demand is such, however, that a waiting list of a year or more is common.

That the Scot has skill in woodworking cannot be denied, as the ancient quaichs and mazers show full well, with their finely feathered woods and excellent finish. There are good craftsmen working in wood in Scotland and capable of making fine furniture. It is, however, a fact that very little in the way of a true Scottish style has ever existed in this *métier* and that much is utilitarian in purpose.

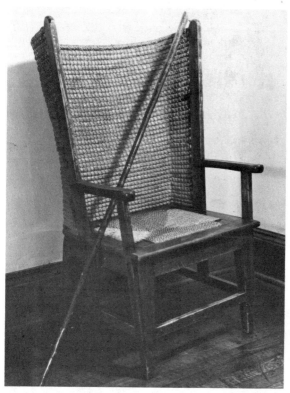

above An Orkney Chair and Shepherd's Crook

Boat-building

In the matter of boat-building, however, the Scot has always been able to hold his own. Admittedly the Clyde today is associated with ship-building, but in the days of the wooden clipper it was Aberdeen and Peterhead which were famed for their fine ships. The east coast rather than the west has always been more strongly associated with wooden boat-building. Most

of the ports along the Firth of Forth and up to the Moray Firth at one time, had its own boat-builders skilled in their craft.

There are still some boatyards to be found in the Forth and further north where wooden boats are still built and craftsmen turn out the wooden trawlers, or smaller fishing boats for inshore work. Watching the skilled craftsman at work on the ribs of such a boat is like turning back the pages of time. The tools today may be power drills and there may be electric lights and power hoists to save time and muscle power, but the wooden ribs and skeleton of the boat rising above the keel form a picture centuries old. The craftsmen themselves are generally from families closely connected with the sea or with boat-building and the satisfaction in their work is reflected in their pride as they speak of 'their' boat.

below Boat-building

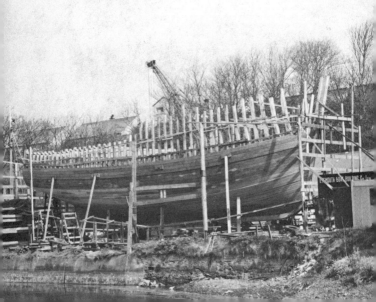

Near Dunbar is one group of craftsmen who have kept well up with the times. As well as turning out plastic dinghies, they specialise in hovercraft parts. Although this may seem a far cry from traditional boat-building, it is perhaps only a natural extension of the same craft. On the far side of the Forth and further to the east at Cockenzie, there are craftsmen turning out wooden fishing boats in the time-honoured fashion. At their launchings there may be heard the triumphant skirl of the pipes as yet another wooden hull takes the water for the first time, the product of old skills and modern craftsmen's work.

Bagpipes

The pipes are to be heard on almost any and every occasion of importance in Scotland, thus it may be something of a surprise for those not aware of the facts to learn that it is arguable as to whether they are truly the national musical instrument of Scotland. There are those who claim that the harp, or *clarsach*, is the real national instrument and others who make similar claims for the fiddle. It is true that the harp, or clarsach, may have older Scottish origins than the pipes, and the fiddle has certainly been played throughout Scotland for many generations. Yet it must surely be admitted that today the bagpipes, famed both in war and peace, are accepted throughout the world as the Scottish national instrument.

It is as much a waste of time speculating about the origins of bagpipes as it is about the origins of golf. Pipes of a kind were known in ancient Assyria and Egypt some 1,500 years B.C. and they are common in many parts of the world. Whether they were introduced to Scotland by the Celts or the Romans,

or whether some form of pipe originated in Scotland itself is really immaterial. Traditionally the pipes were borne by at least two clans at Bannockburn in 1314. They were well known in the 14th and 15th centuries and have been the principal Highland musical instrument ever since, finally achieving the status of national musical instrument, much as the kilt had become accepted as the national dress.

W. L. Manson, writing on *The Highland Bagpipe* in 1901, stated authoritatively that 'the bagpipe had originally but one drone. The second drone was added about 1500 and a third about 1800'. He also stated that 'about the beginning of the 19th century the big drone was added to the bagpipe'. Other writers place this earlier, about mid-18th century. In the National Museum of Antiquities in Edinburgh are a set of bagpipes, decorated with lead, and termed by one writer 'The Great Two-Drone War Pipe of the Highlands'. In general, however, the three-drone pipes were termed the Great Highland Bagpipes. Yet as late as the end of the 19th century single drone pipes were still being played in parts of Scotland.

Bagpipes with only two drones can still be ordered, if required, as there are a number of firms still making bagpipes to order. Unfortunately, however, few of the old traditional individual craftsmen survive. An exception is to be found in the family firm of Glen in the High Street of Edinburgh. Here there are two generations of skilled craftsmen, father and son, still at work at their bench. Here the old methods of making the pipes are still employed and jealously guarded.

The bagpipe consists basically of the bag, from which the three drones, or pipes, emerge on the upper side of one end, with the mouthpiece above them. The player keeps the bag inflated and beneath

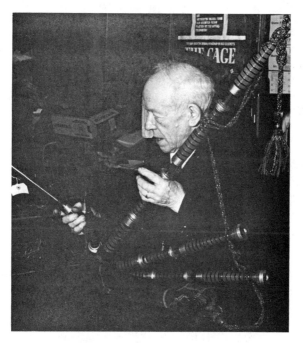

above Bagpipe-maker

the bag is the chanter on which he fingers a limited scale. The chanter and the drones contain reeds. The drones are variously shaped, usually with ivory, or bone mountings, providing a bell-shaped effect at the end with silver or other metal joints. They are usually turned from ebony or similar wood, today, although any hard wood will do. Hawthorn, boxwood and similar woods were once common. The drones are usually joined by tartan ribbon or braided cord hanging down behind and the bag itself is covered with the same tartan. Once the bag is

inflated and in position under the arm the player keeps the pipes playing by squeezing the bag between his elbow and his body, whilst blowing at the same time.

The classical music of the pipes is the *Ceol Mor*, or *Piobaireachd*, the Great Music, popularly termed the *Pibroch*. Traditionally, the piobaireachd dates back to the earliest known great piper, MacCrimmon of Skye who lived between 1570 and 1640. The three principal types of piobaireachd are The Salute, The Lament and The Gathering. In general the piobaireachd tells a story which may be a salute to the birth of an heir to a chieftain, a dirge on the death of a clan chieftain or concerned with a clan gathering.

The Salute, The Lament and The Gathering constitute the great art of piping and are judged individually at the Highland Games.

The popular music of the pipes, which is generally known to everyone, is termed the *Ceol Beag*, or the small music. This is the music of the march, the reel, the strathspey, the quickstep and the jig. It is the music played by the pipe bands, which appeals to Scots all round the world. This is the music which every Scot recognises and which thrills the heart, though it is the piobaireachd which is by far the finer music.

The Ceol Beag is the music which is heard at the Highland Games while the Highland dancing is in progress. Notable amongst the Highland dances is the Highland Fling and the *Chillie Callum* or Sword Dance. Yet, though this is popular dancing music, it has been handed down over the generations and is of ancient origin. The Highland dances themselves have also been passed down over the generations and the dancers often show inherited grace, rhythm and technique.

Fiddles

It is possible that Highland dancing is in fact older than the bagpipes themselves, for it is equally suited to the music of the fiddle or the clarsach. Leaving aside the argument about which came first, there is no doubt that stringed instruments played with a bow did exist in Scotland at a very early period. In the 13th century Thomas the Rhymer has the following verse attributed to him:

'Harp and fedyl both he fande
The getern and the sawtry
Lut and rybid ther gon gan
Thair was al maner of mynstrelsy'.

There was a long tradition of fiddling of a high standard, notably in the north-east and Strathspey areas of Scotland. From James Witherspune in the late 15th century to the famed Niel Gow and his son Nathaniel of even greater contemporary fame, who died in 1831. Scottish musical history has been rich in both fiddlers of great merit and ability, also in able composers of suitable music for the fiddle. The Gow family, who were famed composers, as well as players, left a treasure-house of music, varying from laments to jigs and strathspey reels.

It is difficult to say exactly when the first advanced Italian violins reached Scotland. It was probably about the turn of the 16th century, for it is known that two Cremona violins were offered for sale in 1708. The Scottish fiddle-makers soon saw the advantages of these perfected violins and it was not long before they were making excellent copies. Each maker openly copied a particular make and advertised his work as such. Prominent amongst these craftsmen was the Hardie family, who passed their skill from generation to generation. Individual craftsmen making violins are still to be found.

Clarsachs

The craft of making clarsachs or harps continues despite the fact that of the three principal instruments played in Scotland over the centuries the clarsach is almost certainly the oldest.

The clarsach is depicted on stone carvings of the 9th century and is commemorated in place-names around the country, such as the Harper's Pass in Mull, while references to it in early writings are numerous. There are two fine old clarsachs in the National Museum of Antiquities in Scotland, known respectively as the Lamont Clarsach and the Queen Mary Clarsach. The former is reputedly dated 1464 and the latter a hundred years later, presented to the Lude family in Perthshire by Mary Queen of Scots.

It seems that the use of the clarsach died out around the middle of the 18th century for nearly a hundred and fifty years until the clarsach revival of the late 19th century started by Lord Archibald Campbell. In 1891 he requested the firm of Glen in Edinburgh, well known bagpipe-makers, to make him three clarsachs. He then had six more made by a piano-maker named Buchanan in Glasgow. The latter were modelled on the Queen Mary clarsach, which looks rather like a small concert harp.

Since that date the clarsach revival has continued and there is today a flourishing Clarsach Society, *Commun na Clarsach*. with over four hundred members. One of the finest clarsach-makers was a Yorkshire craftsman named Henry Briggs, who made clarsachs in Scotland up to his death in the 1960s. Fortunately there were others who learned the craft, and as long as clarsachs are played it is certain there will be craftsmen to make them.

Metal and leatherwork

Working in base metals rather than in precious metals such as silver and gold, might, at first sight, seem less exacting and less satisfying to the craftsman, but in many respects the reverse is true. To be able to form a thing of beauty from iron or steel is to prove that the craftsman is artist enough to overcome the handicap of working in a less glamorous metal. It also proves that the craftsman has the deftness of touch and experience to handle metals requiring both strength and skill. In short it is a challenge.

Wrought iron work

There are many examples of fine wrought iron work in Scotland, perhaps the best known masterpieces being the 17th or early 18th century gates of Holyrood Palace and the Lion Gates of Traquair House in the Borders. It is said that the latter have been firmly closed ever since Prince Charles left Scotland.

They were, possibly, the inspiration behind some lesser known but fine wrought iron work of the 1920s at Skirling, Peebleshire. It may be argued that there is nothing essentially Scots about this work, but certainly the artist, Thomas Haddon of Edinburgh, and his patron, Lord Carmichael of the old Border family of that name, were Scots enough and there is an element of puckish fancy and whimsicality involved which is a notably native trait.

After examining the Traquair gates it is said that Lord Carmichael invited Thomas Haddon to start

work on various pieces for him. With each piece he received his fancy grew and soon wrought iron work proliferated, not only on latches and doorhandles inside the house, but outside as well. Wrought iron tulips, lilies, irises and red-hot pokers stand out against the sky and a wrought iron window box holder displays a fine selection of wrought iron roses. Wrought iron rabbits are chased endlessly by wrought iron dogs and surmounting it all is a magnificent 'devil atop the world' wrought iron windvane. To see wrought iron run riot it is only necessary to visit Lord Carmichael's old home at

above Wrought Iron Gates, Lennoxlove

Skirling. Yet it is also an indication of what fine craftsmanship can achieve with unlikely materials. There is today still fine wrought iron work to be seen in Scotland, but it is questionable whether a truly native style has been achieved.

Pewter

One metal which undoubtedly suited the Scots temperament was pewter, and in pewter craft a distinctively Scots style emerged, strong, pleasing and individual. From the turn of the 15th century onwards the *peudrars*, or pewterers, are included in the records of the Hammermen of Edinburgh. Until the middle and late 17th century, however, few examples of their work have survived. Thereafter some good examples of ecclesiastical plate and other vessels are to be found.

It was the principal metal in domestic use in Scotland, being used for plates, jugs, dishes and drinking vessels. Toddy ladles, snuff mulls, snuff boxes and tobacco jars were all also made from pewter. So were the various measures used for drinking and it must be borne in mind that these were quite different from England until theoretically standardised in the 18th century. The Scots measures were four gills one mutchkin; two mutchkins one chopin; two chopins one pint—equal to three English pints!

The favourite pint measure which was commonly used for every drink from ale, to claret or whisky, was known as the *tappit hen*. This was a broad-based vessel with a high neck and hinged top, and an S-shaped handle which had a prominent thumb-piece on top. The name it is thought is derived from the French 'topynett' meaning a quart measure. The

shape, too, has a similarity to the Normandy cider measures. Be that as it may, however, the Scots developed a distinct and pleasing style in pewter, which was distinguishable well into the 19th century.

Whisky stills

In copper, also, the Scots showed themselves distinctive craftsmen, but here in particular they developed a close affinity with another old Scots craft, that of distilling whisky. In the 17th century the craft of distilling whisky was widespread at a domestic level. As the 18th century progressed, particularly from the 1780s onwards the southern Parliament introduced complex and steadily increasing taxation on distilling. At one stage the duty was based on the volume of the still, hence the faster the spirit could be distilled the less tax was paid. This spurred distillers and coppersmiths to exert their ingenuity and it was not unknown to work off an 80 gallon still in $3\frac{1}{2}$ minutes. Such oppressive laws merely resulted in inferior spirit and illicit distillation. By 1800 so greatly had the law been brought into disrepute that the coppersmiths of Inverness openly displayed a still above their doorways to attract custom. Yet it was then that the distillers and coppersmiths developed the modern shape of still in use today.

In 1823 the law was radically altered. George Smith took out the first licence in Glenlivet and, from being little more than a cottage craft, whisky distilling steadily emerged as the great industry it is today. Yet even now the basic principles of distilling malt whisky remain unchanged.

The finest Highland barley is steeped in the best Highland water. It is then spread out on the floor of a

barn and turned daily while it begins to germinate. Next it is slowly dried over a peat fire. It is then soaked in hot water in the mash tun and becomes known as *worts*. With the addition of yeast the fermentation process begins and finally the mixture is put through two pot stills. From the first still the mixture which emerges is termed 'low wines' and from the second as 'raw malt whisky'. It is then matured in wooden casks for eight to fifteen years and becomes in the process the finest drink ever invented by man. Although a full-scale industry today, the crafts and skills involved are still considerable.

Coopers

A good example of the craftsmen still to be found in the Highland distilleries is that of the *cooper* or cask-maker, an increasingly rare craftsman elsewhere in Britain today. The craft is one of great antiquity, going back to the days of the Romans. The staves are best made of well-seasoned oak, each properly cut with bevelled edges to form a tight join. The staves are arranged in a circular frame, and the lower half fitted with truss hoops, prior to the upper end being drawn together with a rope tightened by a windlass. The ends of the staves are then bevelled and the heads and hoops fitted. Such casks must not only be watertight, but must be strong enough to withstand the strain of transportation.

Admittedly today there is elaborate machinery which has, to a large extent, superseded the labour involved, and it has therefore become an industry rather than a craft. Yet even today the cooper requires a full apprenticeship and considerable skill. In the distillery his craft is still a vital one, for once

the whisky has been twice distilled in the gleaming copper pot stills, it must be matured, in the cask, preferably old sherry butts. This is where the cooper's skills are still required. Without a combination of the crafts of the coppersmith and the cooper, Scotch whisky would never have achieved the perfection that it has attained today.

Gold and Silver work

There was never any danger of gold and silver work becoming an industry, if only due to the scarcity and value of the basic raw materials. The Scottish gold and silversmiths did not appear as an organised craft until the second half of the 15th century. Nor were there ever sufficient gold and silversmiths to form their own craft, but instead they were incorporated as a part of the Craft of Hammermen. This included the pewterers, cutlers, blacksmiths, locksmiths and armourers, as well as the coppersmiths and other workers in metal. From the 16th and 17th centuries, and through to the 19th century, they developed as provincial craftsmen attaining a high standard of national workmanship, each with their own particular assay marks denoting the place of origin of their work.

The history of Scottish gold and silver craftsmanship virtually ended with the Statute of 1836 requiring assay marks from Edinburgh or Glasgow for all plate produced in Scotland. Until then gold and silversmiths had been found in many towns, large and small, throughout the country. Aberdeen, Arbroath, Banff, Dundee, Elgin, Inverness, Montrose, Perth, Tain and Wick to the north and Greenock to the west all contributed provincial silver work of note, particularly during the 18th and 19th

centuries, quite apart from the work of Edinburgh and Glasgow.

Unfortunately there is a great scarcity of Scottish gold or silver work prior to the Reformation. In part this was due to the attitude common in Scotland in the 16th and even in the 17th century, which viewed gold or silver plate, however finely wrought, merely in terms of so much bullion to be melted down if required. A lot of extremely fine work must have been melted down in this way over the centuries, either to produce more modern work, or simply to convert it into more easily handled and readily assessed ingot form. During the Reformation particularly, much extremely fine gold and silver plate must have been lost in this manner.

One of the earliest examples of precious metal work and also one of the more remarkable preservation stories concerns the famous St. Fillan Quigrich, or Crozier, a silver-gilt outer case enclosing an older bronze crozier head. There is some remarkable scroll-work ornamentation and a large jewel is set in the pendant head beneath the figure of an ecclesiastic, possibly intended to be St. Fillan himself. Although the Quigrich is reputed to have been carried at Bannockburn, the family of Jore, Doire, or Dewar, were not associated with it until they were appointed hereditary keepers in 1428. As late as 1782 Pennant discovered a Dewar descendant working as a labourer, but still acting as hereditary keeper of the Quigrich. A later descendant emigrated to Canada, from where the relic was eventually obtained in 1876 and placed in the National Museum of Scotland. For nearly 450 years the Dewars had fulfilled their trust, but regrettably the Quigrich itself is thought to have been the product of a foreign craftsman, for the style

is not representative of the Celtic work of that period.

The earliest authentic piece of Scottish mediaeval silver craft known, appears to be a mace at St. Andrews University, which has been identified as originally owned by the old Faculty of Law. The first records of it appear to be of around 1461, although it is regarded as early 15th century in origin. It is also quite definitely identified as the work of Scottish craftsmen. During the ensuing century there are few examples of Scottish craftsmanship in this sphere.

During the 16th century the standing mazer, or wooden bowl on a metal stand with a metal rim, in various forms, was produced by Scots craftsmen, showing workmanship and decorative skills of the very highest order. James Gray, silversmith of the Canongate in Edinburgh, was responsible for two of the finest, known as the Tulloch and the Galloway Mazers, produced about 1557 and 1569 respectively. By this time Scots craftsmen had attained the highest degree of skill and craftsmanship that could be desired.

Almost inevitably the goldsmiths and silversmiths became the élite craftsmen, for in effect they also acted as bankers. The classic example was George Heriot, goldsmith and silversmith to James VI, who went south with his monarch when he became James I of England, and prospered sufficiently to endow the Heriot Hospital and other public works in Edinburgh on his death. In his case the banker appears to have predominated, for though 'Jinglin' Geordie', as he was called, is known to have lent his sovereign large sums of money, no silver work can be traced to him.

Particularly Scots in character was the quaich, a

common form of shallow wooden drinking bowl with two or more projecting handles, found throughout Scotland. Originally hollowed from solid wood, they were later delicately feathered with sections of contrasting woods, plane, laburnum, walnut, even ebony. During the 17th century silver mounts began to be applied to many of these favourite drinking bowls to preserve them. Gradually rims, bases, lugs or handles, and silver hoops began to be introduced as reinforcements. Finally the logical stage was reached of making all-silver quaichs.

Another particularly Scottish form of drinking vessel was the small mug, known as a 'thistle' cup, which first began to appear in the last two decades of the 17th century. They had a rounded base and applied lobes divided from a gracefully belled mouth by a central band, and were intended to suggest the form of a thistle. The delicate S-shaped handle is generally ribbed. Although produced in towns throughout the country, from Inverness and Aberdeen to Glasgow and Edinburgh for a good part of the 18th century they varied remarkably little.

In the later 17th century there was a tendency to follow shapes which were fashionable in the south, but for another century at least the Scots provincial craftsmen in small burghs continued to maintain an extremely high and individual standard of craftsmanship. The plainness, even severity of the Scottish styles in comparison with the south, or foreign styles, was not the least of its attractions. Looking at some of the teapots, dinner services and tableware, or other silver work of the 18th century it is astonishing to see what remarkably clean lines and fine standards were achieved by provincial craftsmen in such small towns as Tain, or Wick. These high standards were carried

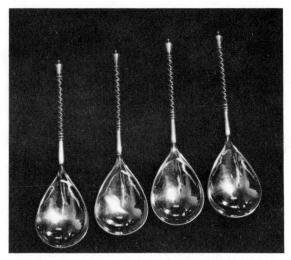

above Modern silver work

on until the 19th century and the 1836 Act, already mentioned. Thereafter there followed a gradual deterioration into Victorian mediocrity and worse. Only in recent years has there been something of a recovery, with individual Scottish craftsmen pursuing their own individual styles and achieving a high standard of craftsmanship.

Guns

During the late 17th century and throughout a great part of the 18th century there was an interesting tie-in between the gunsmiths and silversmiths in certain areas of Scotland, notably at Doune in Perthshire. The making of firearms seems to have flourished in Scotland from the 16th century onwards and the gunsmiths, or dag-makers as they were generally

known, were also part of the Craft of Hammermen. The few remaining Highland guns have an almost Moorish appearance with curving butts and long barrels. The engraving and ornamentation of some of the guns surviving includes mother of pearl and bone inlays, as well as intricate scroll and flower patterns engraved on the metal of the locks.

Examples of dags, or pistols, manufactured in Scotland in the 16th century are rare, but examples showing fine engraving on silver and brass mounts are to be found. As a useful guide to dating guns, the snaphaunce lock, with separate steel and pan cover, continued until around 1700. The 'dog' lock combining steel and pan cover with a half-cock position lasted only from about 1665 to 1690, being followed by the flintlock, which lasted until the introduction of percussion around 1820. Right and left hand locks were common until about 1700.

During the second half of the 17th century the gunsmiths in the east coast Lowland towns developed a long-barrelled pistol with a heart-shaped butt. This was generally made of steel throughout which inhibited decoration, but inlays of silver were sometimes finely engraved. An outstanding example is to be seen in the Royal Scottish Museum with inlays of brass and silver executed in rosettes, thistles and tulips.

In every respect, however, the finest products of the Scottish dag-makers were those weapons produced by the master craftsmen living in or around the village of Doune in Perthshire especially during the period just prior to 1700 until around 1790. These beautifully balanced dags, with their butts terminating in a characteristic double scroll device or ram's horn effect, were wonderfully proportioned, richly decorated and engraved in silver or gold and remain

unsurpassed in their sphere. The names of craftsmen such as John Campbell, Christie, or those four generations of Caddells, who all came from this small area deserve to be remembered. They achieved a remarkable affinity in style with the old Celtic patterns.

On the delicate scroll work, the inlaid tracery appears almost to be silver lace encasing the pistol in some of the finer examples. The merging of butt and barrel is a masterpiece of line and precision. As well as being excellent pistols these are works of art and the surprising thing is, that from around 1725 to 1790, at the time when the Disarming Acts were at their peak in the Highlands, these pistols were being turned out in a steady flow from this small Highland village. From the 19th century onwards there is a steady deterioration in style and craftsmanship.

At the same time there were other gunmakers in Stirling, Dundee and Leith and in particular, Thomas Murdoch of Edinburgh, who made similar pistols of a high standard though with rounded butts.

Fortuitously, however, it was another Scot, the Rev. Alexander John Forsyth of Belhelvie near Aberdeen, whose ingenuity was to revolutionise gunmaking with his invention of the percussion lock in 1807. He was a keen wildfowler and experimented on his own initiative with fulminate of mercury as an igniting agent to replace the often faulty flintlock. Despite the fact that his invention was rejected by the Army, Forsyth filed a patent application and within twenty years few sportsmen were continuing to use flintlocks, although it was to be 1840 before the Army first turned to using his invention.

The Scots gunmakers continued to produce fine guns and certain names remained outstanding. With the introduction of the breech-loader the craft of

gunmaking reached its heights. There were various craftsmen involved in the manufacture of guns at this period. First, there was the *barrel forger* who forged the barrels, heating and hammering three bars of iron intertwined round a central mandril. This was followed by the *barrel borer and filer*, who bored away the interior of the barrel by degrees to reach the correct dimensions required. If a rifle, the rifling would have to be cut by this craftsman. Then came the *lock body and furniture forger*, who forged the lock plate, then using molten brass and suitable moulds produced the butt plate, trigger guard, triggerplate, fore-end cap and lock bolt plate. These parts would then be filed and finished smoothly. Then the ribs, lumps and loops would be fitted to the barrels and the barrels joined to the body. The locks were now filed and then the stock was added by the craftsman known as the *stocker*.

Traditionally the stock is made of walnut, though other woods were used in early guns. The *maker-off* then carved the stock, inlaying and carving orna-mentation as required. The gun was then stripped, finished, including the locks and the *engraver* set to work on the metal parts. Finally came the polishing and browning. Just how many of these crafts were performed by the same man varied considerably, but a true craftsman could make a gun from start to finish.

During the 19th century the number of gunsmiths in Scotland making shotguns and rifles increased rapidly in proportion to the growing numbers of sportsmen coming north for the shooting. Such names as Dickson, Harkom, Henry and Mac-Naughton, to mention only a few, were soon pro-ducing fine sporting guns, the equal of any in England. Typical, perhaps, though more successful

than most, was the progress of the firm founded by master gunsmith John Dickson in Canongate, Edinburgh, in 1820. In 1842 his son John, another master craftsman, moved to premises in Princes Street. Here he and his son John, the third in line, produced guns of a high standard for sixty-five years, before moving once more to 21 Frederick Street in 1907.

In the late 19th century Dickson and MacNaughton were involved in a notable lawsuit as to which was the rightful inventor of a form of action for a breech-loading shotgun. Known as the 'round action', this was basically a sidelock mounted on a central plate, thus combining strength and lightness. Eventually the legal decision in this esoteric craft quarrel went in favour of Dickson. The action was thenceforth known as the 'Dickson Round Action' and although MacNaughton continued to manufacture a similar action, it remained unique to Scottish gunmaking.

Although at this time, around the turn of the 19th century, there were about 200 gunsmiths in Scotland, the competition from mass production in Birmingham and high quality guns in the south led to many mergers and bankruptcies. The process continued between the two world wars. Today only the firm of John Dickson survives, still at 21 Frederick Street and still producing hand-made examples of the now famous 'Dickson Round Action' gun, the only remaining example of the Scottish gunmaker's craft.

Rod-making

Two other examples of crafts for which Scotland was once famed are also to be seen in Dickson's today, namely those of rod-making and fly tying. Each of these now tends to be a part of a factory process

rather than a true craft, but in the past rods of greenheart and split cane were made by craftsmen of Martin's, one of the firms now merged with Dickson. Even today the flies used in fishing the Scottish lochs and rivers are hand tied, the product of craftsmen rather than of machines.

Swords

Although most weapons may be bought in Dickson's, including modern representations of the skean dhu, they seldom sell swords, chiefly no doubt due to lack of supply rather than demand. Yet Scottish swords have an interesting history from the 15th to the 18th centuries. From the typical *claidheamh-mor*, the two-handed claymore of the Highland chieftains depicted on tomb slabs throughout the Western Isles, to the basket hilted *broadswords* of the period around the '45, the Scottish armourers produced a distinctive weapon.

The main development of the claidheamh-mor, or claymore, seems to have taken place during the 16th and up to the middle of the 17th centuries, but few examples have survived. A transitional example between this and the broadsword of the 17th century is to be seen in the National Museum of Antiquities. The description of claymore is often wrongly given to the basket-hilted broadsword which developed in the 17th and 18th centuries.

Three stages in the evolution of the broadsword have been noted. Initially a rare type is to be found with the basket hilt of ribbon metal with short counter curved quillons. In the next stage the hilt is of thin iron bars joined to a junction plate where the counter guards cross. The final stage shows the junction plate much enlarged, notched and pierced,

as was the counter guard and the bars may be fluted.

It is almost entirely in the hilts that the swords are noteworthy. The blades were invariably of foreign manufacture, and although often German, or Spanish, frequently stamped Ferara, variously spelt, after the Italian swordsmith, Andrea Ferara. The majority of these hilts, were made in Stirling or Glasgow, and reached their peak around 1700 to 1745, but one remarkable solid silver hilt was made by the Edinburgh goldsmith Harry Beathune, and is now to be seen in the National Museum of Antiquities. The only other example of such a sword hilt known, is the magnificent one by William Scott of Elgin in the collection of H.M. Queen. The average hilt-maker seldom used silver to any extent and these are quite out of character in that respect. Some of the more highly-prized specimens of these swords, however, have Jacobite inscriptions on the blades, or such sentiments as 'Prosperity to Schotland and no union'.

The evolution of the carving on the handles of the dirk and skean dhu has already been noted and it is interesting to observe that the Celtic influence apparent there coincided with the Celtic ornamentation of the Highland dags. The dirk was generally kept in a handsome sheath of leather attached to the waist belt. The sheath might be plain or have some ornament, tooling and straps of silver, or brass. A notable feature of some sheaths was a miniature knife and fork inserted one above the other with the heads projecting. As the dirk handles deteriorated in the late 18th century and in the 19th century, changing into bulky thistles with massive cairngorms mounted on top of them, so the sheath became elaborately bound in silver. Like the later dags they were intended for show not use.

Targes
The *targe*, or Highland shield, was another aspect of Scottish craftsmanship which should be considered. Few survived the Disarming Acts, but there are some good examples in the Royal Scottish Museum. They were circular in shape, about twenty inches across and made generally of two layers of oak with the grains crossed. These would be about half an inch thick, covered with cow hide nailed to the surface by a design of brass studs. Sometimes a central boss was added in which a spike could be screwed so that it could be an offensive as well as a defensive weapon.

There were usually three forms of ornamentation. In one, the studs form a star. In another the studs form concentric circles, and in the third there is a central panel with four or six surrounding panels of studs centred around a brass boss. In each case the beauty of the targe largely depends on the tooling of the leather, which in some cases recalls the runic carvings of the Western stone slabs. Very occasionally colour is used and sometimes with very fine results, as in the example belonging to Macdonald of Keppoch in the Royal Scottish Museum. Dating them, however, is generally difficult. It can merely be noted that the early 17th century targes are usually ornamented on a small scale, whereas towards the mid-18th century there is much more brasswork apparent.

It is perhaps not surprising that there are a number of targe-makers at work today making replicas of these handsome shields. Among them is one, Mr. Andew Barr of Oldhamstocks, East Lothian, who has developed an old method of working with leather to produce not only targes, but also emblems and heraldic devices as attractive lightweight wall decorations. Yet nearby in Dunbar is a traditional

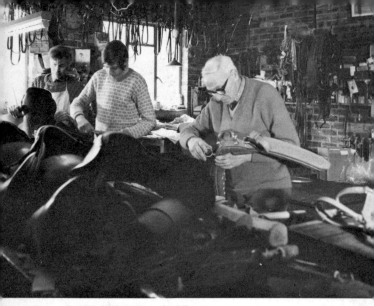

saddler, Mr. William Main, with three generations of craftsmen of the same family working together at their ancient craft. There is still ample scope for craftmanship in leather.

Sporrans

While considering leather work and the targe, mention must also be made of the sporran. This originated as a simple mediaeval draw string pouch, or purse, attached to the waist belt. In 17th century portraits it is seen as a leather pouch with leather thongs which hang down as tassels. By about 1700 a clasp top had been introduced, generally of brass and semi-circular in shape. Apart from plain leather or hide, deer, otter, badger and even seal skins seem to have been used. During the 19th century, however, the sporran developed into a peculiar, hairy and

tasselled adornment, perhaps the most debased aspect of Highland dress.

General David Stewart of Garth, who in 1822 wrote two volumes on *Sketches and Character, Manners and Present State of the Highlanders of Scotland*, noted that the belt which had been used by the Highlanders: 'was of strong thick ox leather and three or four inches in breadth, fixed by a brass or silver buckle in front . . . but is now entirely disused in the Highlands'. Another contemporary observer of a similar period referring to the shoes issued to the Highland regiments spoke of: 'thin low-quartered buckle shoes which let in all the wet'.

below Two generations of Sporran-makers

The Victorian revival of the kilt saw the introduction of absurd hairy sporrans and of a thinner version of the belt described by General Stewart. In the brogues which it was decreed should be worn with the kilt, emerged another example of thoroughly debased taste. Monstrous, long tongued, indented, patterned brogues for country wear, or dancing pumps with elaborate lacings half-way up the leg, or silver buckled black shoes were decreed as the only footwear suitable. The fact that if the Highlanders wore shoes at all, which was highly unlikely, they were of untanned ox leather like his belt was conveniently ignored. The neo-Gothic myth of Highland dress was in the making.

Buckles and Brooches

In belt buckles and in plaid brooches, however, there was almost certainly some good background of craftwork. The Rev. John Lane Buchanan in his *Travels in the Western Hebrides* in the 1780s, noted: 'It is very common to find men who are taylors, shoemakers, stocking-weavers, coopers, carpenters and sawyers of timber. Some of them employ the plane, the saw, the adze, the wimble and they even groove the deals for chests. They make hooks for fishing, cast metal buckles, brooches and rings for their favourite females.'

The metal plaid brooches produced by such craftsmen during the 17th and 18th centuries show that direct Celtic influence also apparent in the dirk handle carvings and in the dag-makers work. It is thought that these buckles should be attributed to the *ceards* pronounced cairds, who were travelling tinkers, or gypsies, so common in the Highlands up to the 1939 War and still found there occasionally.

The brass brooches are the larger and probably earlier form of this particular type of ornament and some are as large as plates. Their function, it must be remembered, was to hold the breacan-feile, or belted plaid, in position. With the development of the feile beg, or the kilt as it is known today, a brooch was still required to hold the separate plaid.

The brooches may be regarded as of three distinct types. The oldest have their circumference divided into circles or plaques with animals or plants represented in them. In the second type there is a chevron marking with or without a plaque, or medallion. The third type have a very wide variety of designs with zigzags and chevrons and, on occasion, thistles. Silver brooches in the last two types may be regarded as betrothal brooches, as they generally carry two sets of initials and a date. The dates are known to cover the period between 1713 and 1770.

Another form of brooch particularly popular in the 18th and 19th centuries, although with origins possibly dating back to mediaeval times, was the Luckenbooth brooch. This was so-called from the wooden booths, or Luckenbooths, close by St. Giles in the High Street of Edinburgh, where they were sold. These were small silver broochs in the shape of a heart, intended as a bethrothal token. There are many variations in style of the broochs and some are even set with garnets, or pebbles. A very few are of gold and some have initials and the date of presentation. Both these and plaid brooches are reproduced by craftsmen today as a popular and traditional form of brooch.

A less common term for the Luckenbooth brooches was Witch brooches, for it is said they were sometimes pinned to children's skirts to ward off the

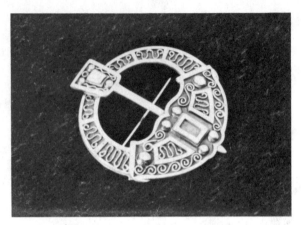

above Celtic Brooch

evil eye. Since the one craft which has not yet been dealt with is witch craft, it may perhaps be appropriate to end with the 'cantrip incantation' for making a love potion, which was used by the witches of Galloway in the dark ages.

> 'In the pingle,[1] or the pan,
> Or the haurpan[2] o' a man,
> Boil the heart's bluid o' the tade,[3]
> Wi' the tallow o' the gled,[4]
> Yellow puddocks[5] champit[6] sma,
> Spiders ten and gellocks[7] twa
> Asks frae stinking lochans[8] blue
> Aye will mak a better stue:
> Bachelors maun hae a charm
> Hearts they hae sae fu' o' harm'.

[1] saucepan; [2] roasting pan; [3] toad; [4] buzzard; [5] frogs; [6] chopped finely; [7] earwigs; [8] newts.

Information Centres

The Scottish Craft Centre, Acheson House, Canongate, Edinburgh, 031–556–8136
The Crafts Officer, Small Industries Council, 27 Walker St., Edinburgh, 031–225–2846
Highland Home Industries, Ltd., 94 George St., Edinburgh, 031–225–2891
The Scottish Tourist Board, 2 Rutland Place, Edinburgh, 031–229–1561

Scottish Craftsmen and Craft Shops

Bagpipe-makers

Glen, J. & R., Lawnmarket, Edinburgh
Hardie, R. G., Crowhill Rd., Glasgow
Inveran House, Dean St., Edinburgh
Kirkpatrick, J., Thistle Wks., Bonhill Alexandria
Macpherson, Hugh, West Maitland St., Edinburgh
Sinclair, William & Son, Madeira St., Edinburgh

Boat-builders

Aberdeen Boat Centre, Greenbank Rd., Aberdeen
Alan, J. & Son, Docking Slip, Gourock
Anderson, J. T., Worworks Ness, Stromness
Arbuthnott & Son, Harbour, Montrose
Brown, A. G., Shepherds Crescent, Burntisland
Buchan, A. & J., Harbour St., Peterhead
Buchan, Hall and Mitchell, Fraserburgh
Cockenzie Slip & Boatyard, Cockenzie, E. Lothian
Coghill, Robert, Vansittart Street, Wick
Duncan, J., Burray, Orkney
Eyemouth Boat Builders Co. Ltd., Eyemouth
Fairlie Yacht Slip Ltd., South Yard, Fairlie
Ferro Cement Boats, Scrabster Boatyard, Thurso
Fletcher, David, Jane St., Dunoon
Gerrard Bros., The Slipway, Arbroath
Hebridean Boats, Old Pool Park, E. Kilbride
Invergordon Boatbuilders, Shore St., Invergordon
Irvin, Richard & Son, Bridge St., Peterhead
Largs Boat Yard Co., Allen Park St., Largs
Loch Ness Marine, Ltd., Canal Road, Inverness
Lothian Marine, Ltd., West Shore Rd., Edinburgh
McAlister, J. & Son, Sandpit Woodyard, Dumbarton

MacCuish Donald, Cromwell Rd., Inverness
Macduff Boatbuilding Co., Crook O Ness St., Macduff
McGruer & Co., Pier, Rhu, Dunbartonshire
McGrouther, R. A., Slipway, Kilcreggan
Mackinnon, Ian M., Broadford, Skye
MacLennan, J., Cromwell Rd., Inverness
MacLennan Marine, Lower Harbour, Perth
Malakoff Ltd., Northness, Lerwick
Miller, James, N. & Sons Ltd., East End St., Monance
Nobel, James, Balaclava, Fraserburgh
Ross, T., High St., Newburgh
Smith & Hatton, East Green, Anstruther
Smith, James & Son, York St., Ayr
Stenton Hovercraft Ltd., West Barns, Dunbar
Stornoway Boat Building Co., Goat Island, Stornoway
Stout, A. C., Grunaby, Westray
Timbercraft, Shandon, Gairlochhead
Waterson, R. J., Scalloway, Shetland
Weatherhead & Blackie, Old Harbour, Dunbar

Clarsach-makers
Firth, I., 87 Hepburn Gdns., St. Andrews
Sanderson & Taylor, Alva, Clackmannanshire

Embroidery and Tapestry
Bell, Mrs. Patricia, Redwood, Auchtermuchty, Fife
Brennan, Archie, 8 Bridge Place, Edinburgh
Cunningham, Ellen, 32 Mansewood Drive, Dumbarton
Edinburgh Tapestry Co. Ltd., Dovecot Studios, Dovecot Rd., Edinburgh
Forbes, Margaret, Rosehearty, Aberdeenshire
Frew, Hannah, M., Craigielea, Chapelton, Strathaven
Hodge, Maureen, 16 Hugh Miller Place, Edinburgh
Johnstone, Mrs. Mary, Palace, Crailing, Nr. Jedburgh
Kindberg, Miss Agnes Marie, 8 Chester St., Edinburgh
McLellan, Miss M., Ninaidi, Achintore Rd., Fort William
Scott, R., The Pendstead, Melrose, Roxburghshire
Shaw, Sax, 25 Howes St., Edinburgh
White, Crissie, 249 Perth Rd., Dundee
Whyte, Kathleen, 57 Montgomerie St., Eaglesham

Furniture-makers *Chairs*
Caithness Chairs, 2 Traill St., Thurso, Caithness
Eunson, Reynold, 14 Palace Rd., Kirkwall, Orkney
Sutherland, A. B., Joiners House, Haster, Wick.

Glass

Airlie, John G., Kirkhill Glass Co. Ltd., Kirkhill Gardens, Gorebridge, Midlothian

Garson, George, 7 Newhouses Rd., East Burnside, by Broxburn, West Lothian

Geissler, Alison, 52 Dudley Avenue, Edinburgh

Gordon, Harold, Greywalls Studio, Forres, Morayshire

Hogg, Douglas, 34 The Square, Kelso, Roxburghshire

Kinnaird, Alison, 369 High St., Edinburgh

Mann, Denis F., 14 Ackergill St., Wick, Caithness

Strathearn Glass Ltd., 14 St. Enoch Sq., Glasgow

Terris, Colin, 9 Sinclair Terrace, Wick, Caithness

Turner, Helen, 51 Juniper Av., Juniper Green

Gunmakers

Dickson, John, 21 Frederick St., Edinburgh

Hornworkers

Carill-Worsley, Air Commodore G. T., Horn Products, Ardnacloich, Moniaive, Dumfriesshire

Duncan, William, Kirkland, Kelton, Castle Douglas

Glenroy Horncraft, Braemar, Deeside, Aberdeenshire

Horncraft Ltd., Kilwinning Rd., Irvine, Ayrshire

McLean of Braemar, 10–12 Invercauld Rd., Braemar

Ross, R. D., Roger Falls, Tarve, Aberdeenshire

St. Inan Products Ltd., Dalmellington, Ayrshire

Thomas Cameron, Lawers Toll, Aberfeldy, Perthshire

Young, James, Comrie Crafts, Comrie, Perthshire

Kiltmakers

Anderson's of George St., Edinburgh

Chisholm, D., Castle St., Inverness

Crooke, H. G., Hill Terrace, Elgin

Davidson, Captain I., Inverallan Mill, Bridge of Allan

Fraser, Ross, Ingram St., Glasgow

Geoffrey, Morningside Rd., Edinburgh

Highland House, Lawnmarket, Edinburgh

Kiltmakers, The, Canongate, Edinburgh

Kilt Shop, The, George IV Bridge, Edinburgh

Kirkpatrick, J., Thistle Wks., Bonhill, Alexandria

Lawson, J. & S., Candlemaker Row, Edinburgh

Macpherson, Hugh, West Maitland St., Edinburgh

Ross, John, Ingram St., Glasgow

Scott, The Kiltmakers, George St., Aberdeen

Smith, Daniel, High St., Dunbar

Stewart, C., 86 George St., Edinburgh

Knitwear

Allan Murray, Waukrigg Mill, Galashiels
Anderson & Co., The Shetland Knitwear, Lerwick
Annette Knitwear, Torpichen St., Edinburgh
Annsmill Knitwear, Leadburn
Aurora Knitwear, Shetland Ltd., Walls, Shetland
Ballantyne, Sportswear Co. Ltd., Caerlee Mills, Innerleithen
Barker, Sam, Douglas Rd., Hawick
Barrie, Knitwear Ltd., Annfield Mills, Hawick
Braemar Knitwear, Victoria Mills, Hawick
Buccleuch Knitwear, Towerknowe, Hawick
Coutts, Theodora, Commercial St., Lerwick
Donaldson Bros., Toll Road Mill, Kincardine
Glenburn Knitwear, Lothian Works, Hawick
Glen Gordon, Berryden Mills, Aberdeen
Glen Lossie Knitwear, Newmills, Elgin
Goudie, New Factory, Lerwick
Harley & Co., Queen St., Peterhead
Harrior & Co., Rose St., Aberdeen
Hawick Knitwear, Princes St., Hawick
Hawico of Scotland, Trinity Mills, Hawick
Highland Home Industries, Bridge St., Aberdeen, *and* Batchin St., Elgin, *and* George St., Edinburgh
Islandwear of Shetland, Hamnavoe
Jack, M. & J., Bowmont St., Kelso
Kintyre Knitwear, Victoria Rd., Hawick
Kilspindie, Market St., Haddington
Larissa Knitwear, Hall St., Galashiels
Lothian Loom, West Linton
Lyle & Scott Ltd., Pinnacle Hill, Kelso
Marchbank Knitwear, Mansfield Sq., Hawick
Maka Knitwear, Commercial St., Lerwick
Murray Bros., Tower Mill, Hawick
Nelbarden (Scotland) Ltd., Mitchelson, Kirkcaldy
Orkney Knitwear, Junction Rd., Kirkwall
Pringle of Scotland Ltd., Old Railway Station, Earlston
Scott & Charters Ltd., Burnfoot, Hawick
Shetland Fashions, Aith, Bixter
Shetland Knitwear, Commercial St., Lerwick
Shetland Woollen Specialists, Hanover St., Edinburgh
Stewarts of Jedburgh, Riverside Mill, Jedburgh
Stuart of Inverness, Harbour Rd., Inverness

Sybil's of Hawick, Buccleuch Mills, Hawick
Thuleknit Ltd., Lerwick, Shetland *and* Jedburgh
Tulloch, John, Shetland Products, Ltd., Lerwick *and*
New Factory, Selkirk
Tulloch of Shetland, Commercial St., Lerwick
Turnbull, George, Fairhurst Drive, Hawick
William, C. N., Teviotdale Mill, Hawick
Williamson, J. W. Garth, Skellister, Shetland

Leatherworkers and Targe-makers

Barr, Andrew, Oldhamstocks, E. Lothian
Hodge, R., East Village, Pencaitland, E. Lothian
Kirkwood, James A., 88 Burrell St., Crieff
Main, William, 9 West Port, Dunbar, E. Lothian
Morris, R., Acharn, Aberfeldy, Perthshire
Thompson, Mrs. L., 28 Admiralty Pl., Beith, Ayrshire

Silversmiths and Jewellers

Angell, A. R., 39 Clydesdale Avenue, Paisley
Auld, John, Braehead Rd., Thorntonhall, Glasgow
Buchanan, Thomas, Dundonald Park, Cardenden, Fife
Cherry, Norman, 15 Coalmarket, Kelso, Roxburghshire
Creswick, Norah, Studio, 20 Harrison Rd., Edinburgh
Davidson, Ian A. R., 13 Merchiston Park, Edinburgh
Derby, Kenneth, 1 Church St., Cromarty, Ross-shire
Dickson, R. A. M., 4 Commonty Rd., Tayport, Fife
Frame, Glen K., 5 Ireland St., Carnoustie, Angus
Gorie, Ola M., 11 Broad St., Kirkwall, Orkney
Grant, Norman, Emsdorf St., Lundin Links, Fife
Hall, W. H., Craigmore, Rothesay, Bute
Harkison, D. W., 44 Marywood Sq., Glasgow
Hodge, David J. F., 6 Portlethen, Aberdeen
Masterson, Luke, 9 Kip Av., Inverkip, Greenock
McDonald, Thea, 56 Craiglockhart Gardens, Edinburgh
Ortak, Silversmith, Kirkwall, Orkney
Rae, J. G., Soundside, Weisdale, Shetland
Seel, Finlayson J., 67 Southbrae Drive, Glasgow
Silvercraft, Market Hall, Inverness
Stevens, Gordon, 204 Canongate, Edinburgh
Stolery, Mrs. Janet F., Silver Workshop, 22 Seafield St.,
Cullen, Banffshire
Stone, R., Portincaple, Garelochhead, Dunbartonshire
Swindale, Owen, c/o The Scottish Crafts Centre
Canongate, Edinburgh
Turnbull, R., Raith Home Farm, Kirkcaldy, Fife

Sporran-makers

Scott, W. E., 110 Causewayside, Edinburgh

Woodcarvers and Turners

Bain, Harry, 36 Leadervale Rd., Edinburgh

Beedie, J. Douglas, John Beedie & Son, East Hendersons Wynd, Dundee

Campbell Allister, 15 Kingsway, Tarbert, Argyll

Crichton, J. & I., Braemar, Aberdeenshire

Crowe, John S., 2 Bower Court, Thurso, Caithness

'The Craftsman', 21–3 Atholl Rd., Pitlochry, Perthshire

Gill, Claude, Arran Gallery, Whiting Bay, Isle of Arran

Hunter, William James, 24 Main St., Chapelton

Katrea Woodcrafts, Duncree House, Girvan Rd., Newton Stewart, Wigtownshire

Kyle, Rollo, 7 Lendale Lane, Bishopbriggs, Lanarkshire

MacDonald, Murdo, Ferry Road, Leverburgh, Harris, Outer Hebrides

Masson, R., Woodturner's Shop, Brodie, by Forres

Norman, Commander Tormod, Jamestown, Strathpeffer, Ross-shire

Pouncey, H., Craigdarroch Estate, Moniaive

Riley, D., Woodcarvers Shop, Cullen, Banff

Scott, G. S., 5 Scoonie Terrace, Leven, Fife

Scott Lodge, J. K., Moonfleet, Shore St., Cromarty

Strachan, Ian, 2 Bellwood Rd., Aboyne, Aberdeenshire

Whyte, Stanley, 33 Main St., Pathhead, Ford

Weaving

Achine Weavers, Inverkirkaig, Lochinver, West Sutherland

Brock, Ursula, c/o Scottish Crafts Centre, Edinburgh

Brown, Mrs. Thorburn, Dalbreck, Gullane, E. Lothian

Bute Looms Ltd., 4 Barony Rd., Rothesay, Bute

Clarke, Bransby, Archbank, Moffat, Dumfriesshire

Dalgleish, D. C. Ltd., Dunsdale Mills, Selkirk

Gurney, D. R., Russell Gurney Weavers, Brae Croft, Muiresk, Turriff, Aberdeenshire

Hamilton, Agnes, Pilmuir Farm, Newton Mearns

Highland Handloom Weaving, 86 High St., Dingwall, Ross and Cromarty

Hunter, T. M. Ltd., Sutherland Wool Mills, Brora, Sutherland

Innes, Ltd., Col. W. A. D. and Mrs., The Old Manse of Marnoch, Huntly, Aberdeen

Inverhouse, Gledfield, Ardgay, Ross-shire
Kyleside Weaving & Handcraft, Bonar Bridge, Sutherland
Lane, K., Rockliffe, Dalbeattie, Kirkcudbrightshire
MacDonald, Lachlan, Cnoc-Ard, Grimsay, North Uist
McKay, Miss E., 37 Mountcastle Drive South, Edinburgh
McPherson, Mrs. Joan, 6 Abercromby Place, Edinburgh
Mitchell, James, Mitchell's Close, Haddington
More, James, J., 12 Loanhead St., Kilmarnock, Ayrshire
Sclater, John & Co. (Orkney) Ltd., Mill St., Kirkwall
Urquhart, Mrs. D., 16 Scone Gdns, Edinburgh
Wood, Mrs. Karin, 11 Eskside West, Musselburgh

Woollen Mills

Ballantyne Bros., March St. Mills, Peebles
Ballantyne, Henry & Sons, Ltd., Tweedholme Mills, Walkerburn
Begg, Alex & Co. Ltd., Tweed Mills, Ayr
Bell, Scotch Tweeds, Buccleuch Mills, Langholm
Blenkhorn Richardson & Co. Ltd., Eastfield Mills, Hawick
Buchan, John M., Ltd., Waverly Mill, Galashiels
Bute Looms Ltd., Rothesay, Bute
Crombie, J. & J., Grandholm Works, Aberdeen
Dickson, Comleybank Mill, Galashiels
Gardiner, Edward, & Sons Ltd., Tweed Mills, Selkirk
Gibson & Lumgair Ltd., St. Mary's Well, Selkirk
Grampian Textiles Ltd., Woodside Place, Glasgow
Haggart, P. & J., Ltd., Breadalbane Woollen Mills, Aberfeldy, Perthshire
Heather Mills & Co. Ltd., Selkirk
Holmes & Allan Ltd., Fielden Mills, Glasgow
Hunter, T. M., Wool Mills, Brora
Johnston, Ebenezer, Gala Mill, Galashiels
Johnston, James & Co., Elgin, Newmills, Elgin
Kynoch, G. & G., Isla Bank Mills, Keith
Laidlaw & Fairgrieve Ltd., Riverside Mills, Selkirk
Laidlaw, Robert, & Sons, Seafield Mills, Keith
Macarthur, Peter, & Co Ltd., Clan Weaving Mill, Hamilton, Lanarkshire
McBean & Bishop Ltd., Glentane Mills, Alva
MacNab, A. & J., Ltd., West Mills, Haddington
MacNaughton, A. & J., Pitlochry, Perthshire

Mercer, Walter, & Sons, Stow Mills, Stow, Midlothian
Neill, R. G., & Son Ltd., Glenesk Mills, Langholm
Paterson, Adam, & Sons Ltd., Wets Mills, Haddington
Pringle, James, Ltd., Holm Woollen Mills, Inverness
Rae, G., & Son Ltd., Raeburn Tweed Mills, Selkirk
Reid & Taylor, Langholm Woollen Mills, Langholm
Reid & Welsh Ltd., Lossiebank Mills, Elgin
Rennie, J. & Co. Ltd., Mill of Aden, Mintlaw
Roberts, George, & Co. Ltd., Tweedholm Mill, Walkerburn
Scott, James, & Sons, Waverley Mills, Langholm
Scottish Crofter Weavers Ltd., Union Terrace, Keith
Scottish Islands Tweed Agency Ltd., Leith, Edinburgh
Stewart, Andrew (Woollens) Ltd., The Perns, Galashiels
Strathmorn Woollen Co. Ltd., Canmore Works, Forfar
Watson, Wm., & Sons (Hawick) Ltd., Dangerfield Mills, Hawick
West of Scotland Home Industries, Ltd., Langhaugh Mills, Galashiels
Wilson & Glenny Ltd., Langlands Mill, Hawick
Woolly Mill Co. Ltd., Ford Mill, Langholm
Wright, J. T. (Trow Mill) Ltd., Trow Mill, Hawick

Wrought Ironworkers
Black, Walter, West Bow, Edinburgh
Bogie, T. & Son, Ltd., 8–10 N.W. Circus Place, Edinburgh
Gow, J., Candlehouse Lane, Coupar Angus
Grant, J. B., Clepington Rd., Dundee
Hadde, Thomas, 37 Roseburn St., Edinburgh
Harrower, Andrew & Son, Whittingehame, East Lothian
Marshall, J. S., Bennybeg Smithy, Crieff
Martin, E. & Son, Closeburn, Thornhill, Dumfriesshire
MacMillan, Duncan M., Gate Lodge, Torlundy, Fortwilliam
McDougall, A., Gorgie Road, Edinburgh
McKerrachar, R., The Aizle, Strathblane
Millar, Alex, & Son, Terminus Rd., Blairgowrie
Thomson, James A., Springbank, Scalloway, Shetland
Weir, Bruce, New Bongate Mill, Jedburgh, Roxburghshire